THE NEW
WINE RULES

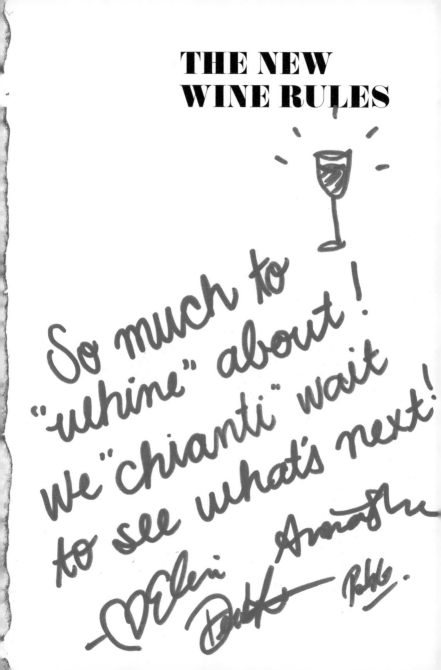

So much to
"whine" about!
We "chianti" wait
to see what's next!

Eleni Amanda
Dutko Rebbe.

THE NEW WINE RULES

A GENUINELY HELPFUL
GUIDE TO EVERYTHING
YOU NEED TO KNOW

JON BONNÉ

ILLUSTRATIONS BY MARÍA HERGUETA

TEN SPEED PRESS
California | New York

CON-
TENTS

INTRODUCTION

Everyone thinks wine experts live charmed lives. When people find out what I do, their heads fill with visions of me being driven around in a chauffeured Benz, tasting rare bottles. And for sure, there are many less fun things to do in life than to taste, critique, and write about wines from around the world.

In truth, my wine life isn't that different from yours. I've walked into plenty of wine shops and gotten lousy advice. I've been tempted by—and burned by—more wine recommendations than I can count. At night, with dinner, I'm as likely as anyone to drink whatever's open in the fridge.

Restaurants? I still struggle through wine lists, and regardless of the fact I have a near-photographic memory (only where wine is concerned), I *still find* plenty of wine on lists that I've never heard of. I've had sommeliers talk down to me more times than I care to remember. And I've been served wines in shockingly bad condition, like the fancy $125 bottle of Grenache I had not long ago, which came to the table so warm I wondered if it was stored next to the pizza oven. (We asked for an ice bucket.)

I love what I do, and each year I get to taste thousands of wines, including many that few people get access to. But knowing a ton about wine doesn't magically improve your wine life.

In fact, an obsession with "wine expertise" in this country may have made it harder for us to enjoy wine. Americans have in many ways been misled by the mystique of wine expertise. We're dazzled by tales of sabering Champagne and blind-tasting bottles of red Burgundy. But these things are really just parlor games. The myth of connoisseurship is that you need to know every little thing, and in truth most wine experts obsess over details that have almost zero bearing on how the rest of us live our lives.

Don't get me wrong: Expertise can be valuable. I've written about wine professionally for about 15 years, including nearly a decade as the wine editor and chief critic of the *San Francisco Chronicle*, the only U.S. newspaper with its own wine section. That means I've written hundreds of articles and tasted tens of thousands of wines, which is to say I don't doubt my opinions about wine are better informed than most. I wrote a book, *The New California Wine*, that documented the rebirth of interest in the state's wines. And I'm the junior wine nerd in our household; my wife imports and sells some of the world's best wines. Our bookshelves are filled with wine books and our walls are covered with vintage vineyard maps.

In other words, it is both of our jobs to know a lot about wine. And both of us have concluded that wine isn't something you need to learn about in classes or by chasing a pin or a diploma. Wine is something that becomes a part of your life in gradual, almost invisible, steps.

I was lucky; I grew up with wine around the house; it was a semi-professional interest of my father and I learned about it from him more or less osmotically, the way other kids might learn about baseball. I never had a grand moment of enlightenment. Then I forgot all about it, went off to college, and became a journalist. Years later, that interest returned, and after I started sneaking wine into most of my stories, I finally proposed to my editor that I write a column. So began my career as an expert.

Expertise, however, comes gradually. Early on in that career, when I was less confident, I made a classic mistake: I pretended to know more than I did, which made me the worst of all things— a wine snob. Once I rejected a bottle of barbera with my pizza because it was "way too tannic." (Barbera is actually known for having almost no tannins; it's a great pizza wine.)

Eventually I became comfortable with admitting what I didn't know. I tasted and drank a lot of wines, and started to put the pieces together. I never wanted to be a sommelier, and I never got an official blessing to be an expert. You don't need one either.

Especially not now. The old ways of wine are fading into the distance. A handful of once-powerful wine tastemakers are now much less powerful. Wine drinkers today are more self-assured, and less reliant on point scores and so-called "expert" wisdom.

All of which made me wonder: What can an expert offer? Certainly the world doesn't need another "drink this, not that" book. Instead, *The New Wine Rules* was born out of the idea that the most valuable thing I can share is a handy summary of the practical things I've learned about incorporating wine into everyday life: how to figure out what you like, how to pick out a bottle for this weekend's barbecue, when to splurge and when to keep it low-key.

For that reason, you won't find a lot of talk here about varieties and regions. A thousand other books have covered those things, and they can help you dive deeply if you choose. They're details to learn at your own pace and in your own time, and frankly the world of wine has grown so vast that it's impossible for anyone to know it all. What matters is learning to figure out what you like.

The nice part of doing that is that now is the best time in history to be drinking wine. The sheer diversity of flavors and styles and grapes available today is greater than ever. If I can share one bit of advice as you read along, it's this: Drink wine with joy. Perhaps that's obvious, but remember that at least in America, the past couple generations of wine lovers have spent their lives guided by fear—of displaying bad taste or revealing what they don't know.

Screw that. Fear was the guiding principle of the past. We're officially done. Wine is too great a thing to be limited by fear.

So drink with joy—and never let go of your curiosity. Wine is an endlessly complex and fascinating part of our culture. A curiosity about it can span a lifetime, although it doesn't have to. It certainly has filled up my life. Now is the time to share some of what I've learned along the way.

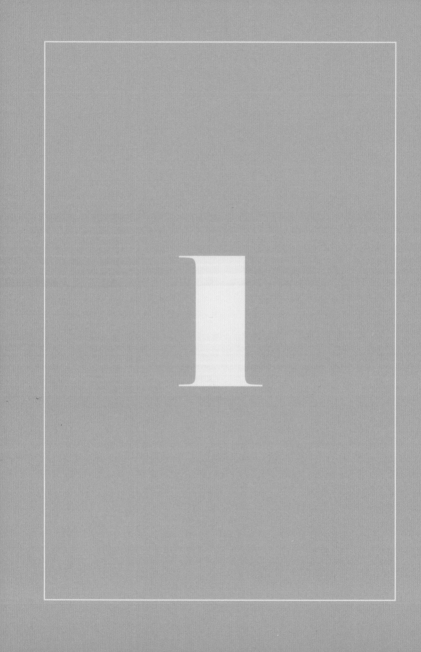

1

THE
BASICS

RULE 1

Drink the rainbow.

The world of wine today is more diverse and interesting than it ever has been. It's a shame that the vast majority of wine drinkers don't take advantage of it.

This isn't anyone's fault. By and large, we're creatures of habit, and wine is, as much as anything, a habit. If you like Chardonnay, you'll probably keep drinking Chardonnay, because it's known to you. And once you get attached to Brand X, you'll probably keep drinking Brand X unless someone gives you a good reason to switch.

And the wine industry knows, deep down, that most of their customers are still driven, more than anything, by fear. So they like to offer familiar, narrow choices. Do you want white or red? Pinot Noir or Malbec? France or California? How about another Prosecco?

The good news is that this way of thinking was largely promoted by the generation that started drinking nearly forty years ago. The 1980s were a time when wine was something mysterious that needed to be decoded. That was an era of simplistic slogans and choices.

Today is different. Today we all have the freedom to drink without borders—to enjoy an ever-changing roster of styles and regions and grapes. Gamay Noir from the Sierra

Foothills? Skin-fermented Muscat from Pantelleria? Why not?

There's an easy way to approach this new wine world. We're often told to eat the rainbow—to select a range of foods in diverse colors, in order to diversify our diet. And in a broader way, that's how we eat today. We're less interested in appetizer plus main course than in grazing. We crave a pixelated approach to our cuisine, an ever-changing set of choices.

That isn't to say that old favorites aren't welcome, in food and in wine. But do you really want to be the person ordering Pinot Grigio because it's safe and inoffensive, or holding forth on the difference between Chablis and Chardonnay? (A tip: Chablis is a Chardonnay.) Or do you want to start having fun with your wine life?

I propose a similar approach with wine: Drink the rainbow. "White" wine today isn't just white. It could be pale green or deep yellow. Red can be so light that it's fuchsia, or as dark as ochre. There are hundreds of useful grapes, some better and some worse but nearly all worth discovering. But don't even worry about grapes so much, because they can be made in a wide range of styles. There are many styles of winemaking to

transform those grapes. There are hundreds of wine appellations. There are a thousand shades of rosé, and beyond pink wine, there's orange wine, too (see page 35). There are wines made under a veil of yeast and wines that are fizzy, wines that taste like rocks and wines that taste like the wisdom of age.

That's the guiding principle for this book. You don't need yet another expert to explain that wine is white or red, or maybe other. You need a framework for embracing this weird, wonderful wine world that we get to live in.

Many years ago, a wise frog once sang: "Rainbows have nothing to hide." Quite literally, they show us all their stripes. That's very much where wine is headed today. So drink the rainbow. You'll be glad you did.

RULE 2

Forget "the best" wines. Drink good wines.

In the past twenty years, many of the world's finest wines—much of the top Bordeaux and Burgundy, and many California Cabernets, for instance—have become prohibitively expensive. (There are a few notable exceptions, like German Rieslings.) This isn't to say you shouldn't drink them if you can. But don't worry about buying "the best." The best is often *very* good. But not always. And there are thousands of very good wines in the world that haven't been anointed "the best" for one reason or another (usually geography). Spend your time learning everything you can about *those*. Interesting and well-chosen is better than fancy.

RULE 3

A good wine-store employee is your best friend.

If you want to learn about wine, the single most important thing you can do is find a great local wine shop and get to know the staff. As they get to know your tastes, they'll be able to guide you to the wines they love— and the wines they think you'll love, too. Take a look at the next page for some tips for buying wine like a pro.

FIND A GOOD STORE.

It should cover many wine regions (unless it specializes in just one) and have salespeople who can tell you about the wines in detail, including how the grapes were farmed. It should focus on great independent importers and producers. Think of it as being a bit like choosing an independent bookstore.

FIGURE OUT IF THEY'RE STOCKING GOOD STUFF.

A great shop has a diverse selection from small wineries—bottles you haven't seen in the supermarket, made by people with identifiable names rather than large companies.

BE CONFIDENT.

Too many wine lovers are still nervous about talking with shop staff. *You're* the customer, and you shouldn't have to pretend to know more than you do. Tell them what you want, and they should follow your lead—not sell you what they want to sell you. Don't feel the need to use jargon. Use language that's comfortable. If you feel intimidated, it's not a good shop.

BUILD A RELATIONSHIP.

Like any other boutique store, wine shops rely on regular customers whose tastes they can learn. You'll often be rewarded with advance notice on sales and tastings.

TRY THE CHAMPAGNE TEST.

Finally, one easy rule of thumb: Champagne is the wine with perhaps the clearest split between big corporate names and little ones. So if you walk into a wine shop and recognize more than half the Champagne brands on the shelf (unless you're a wine geek), keep looking.

Don't be intimidated by wine jargon—most of it doesn't mean much.

You should feel free to talk about wine however you like. Some words are specific and technical ("residual sugar," see page 22) and some are commonly understood ("tannic," see page 21). But many are fanciful and expressive—fun but subjective. A few are clichéd ("really sexy") and some ("refreshing") are essentially meaningless. Unless you're a professional talking to professionals, use the words most comfortable for you.

That said, it's worth trying to avoid pretense. (Do you really need to say a wine has "a hint" of anything?) And the world of wine talk has a few common pitfalls worth avoiding (see opposite).

"SUCH A FEMININE WINE."

Wine is complicated enough; no need to bring in gender. Lots of other adjectives (rugged, delicate, intense, nuanced) work just fine.

"THIS IS SO SMOOTH."

There's a fine line between terminology and jargon. "Smooth"? This isn't a razor ad! "Soft-textured" or even "silken" will be more precise. (Let's not even talk about "chunky.")

"POUR ME SOME JUICE!"

Wine is plenty fun without the faux populism. "Juice" is wine before it becomes wine. Bottles do not need to be "crushed." Shots are for something with higher proof.* Let the term "unicorn wine" die a quiet death.

* Although the Chambong, a sort of mash-up of Champagne flute and beer bong, is pretty great.

"CHERRIES, BLACKBERRIES, A WHIFF OF RED CURRANT . . ."

Beware the fruit salad. It's fun to identify flavors, but a little goes a long way—and a lot will make people think you have a produce-aisle fetish. Instead, consider describing the relative spectrum of flavor (dark fruit, bright fruit).

"YOU CAN TASTE THE TERROIR . . ."

Are you smelling and tasting distinct things (like gunflint in Chablis) typically expressed by a certain grape grown in a certain place? Or are you tasting earthiness? The former might reflect *terroir*, a complicated term that essentially means "somewhereness" and refers to the way wines from certain places can taste a specific way. The latter describes the smells and flavors of things like fresh (or not fresh) soil.

Really, you only need to know a few key wine terms.

We use lots of words to describe the smell and taste of wine. They can be confusing because they're *implied*. Wine is almost always made just from grapes (although if you taste the vanilla-like sweetness that comes from oak, it is derived from trace elements found in wood). So if I say I smell licorice or taste blackberries, some chemical compounds in those things might be present, but they didn't literally go into the wine. In which case, what do these words really mean?

FRUITY

Wine tends to taste like almost any fruit except grapes. You might think about specific fruits (cherries, oranges), but you can also think about the sort of fruit—bright flavors like lemons or dark ones like blackberries—and how it fits with the wine. Fruity isn't the same as sweet, but a fruity wine often has fewer of the other aspects, and wines can "lose" their fruit flavors with age.

HERBAL

The smells and tastes of herbs—anything from fresh-cut grass (think Sauvignon Blanc) to dried sage. This can come from the grape (Cabernet Franc, for instance, often has an aspect like chile peppers) and its relative ripeness, and even the use of whole grape bunches (stems and all, rather than just berries). Ultimately herbal should be a *positive* term, versus *vegetal*, which implies "underripe."

SPICY

A sense of dried spices that accent the fruit and other aromas—anything from juniper to nutmeg. Many wines are often described as *peppery*, especially Syrah, which contains the compound rotundone, also found in peppercorns and rosemary.

DRY

Meaning, not sweet. This is a technical term, indicating there's almost no sugar left from fermentation, but it's also a perception: a taste that doesn't reveal any sugar. Some dry wines may taste like they have sugar, hence the term "fruity" (see page 22).

MINERAL

The taste of rocks and other nonplant elements, like salt. There's endless debate as to whether mineral components are actually present in wine, and if so, how they got there, but some wines undeniably taste of things like gunflint or chalk. (And yes, many wine people have literally tasted those things.)

ANIMAL

Could be a positive thing, as when someone smells, say, smoked ham in their wine. (Syrah, again, does this sometimes.) Or the bloody twang of rare beef. Could also be a bad thing, if it smells like a sweaty horse saddle (usually a sign of problematic bacteria) or wet dog (it could be "corked," see page 54). It's good to be specific.

TANNIC

Tannins are naturally occurring, slightly bitter compounds present in wine grapes. (That raspy, drying, tealike sensation when drinking wine? Tannin.) Different grapes naturally contain more or less tannin (even white grapes—so yes, wine from white grapes can be tannic!) and winemakers can extract varying amounts. "Tannic" is generally used when the tannins are excessive.

RUSTIC

One of those tricky words that essentially means "not polished." For much of the late twentieth century, it was usually a putdown, indicating the wine wasn't elegant. Today, a lot of drinkers have more compassion for wines' rough edges, and its meaning has become more complex.

There's a difference between "fruity" and "sweet."

* Riesling and some other white wines, like Chenin Blanc, can be made in a range of styles: dry, sweet, and in between (half-dry; *demi-sec* in French or *halbtrocken* in German). All these styles can be delicious, and a good one will indicate its sweetness on the label. Don't be afraid to ask whether a wine is dry or sweet.

** Not the same as contemporary New World Chardonnay. Many, from places like Australia and even California, are made today in a dry and less-fruity style.

The words "sweet" and "dry" have specific, technical meanings when referring to wine, and they have to do with *residual sugar*. Wine is typically made by converting grape sugar into alcohol; usually all the sugar gets converted, although sometimes a bit is left over (that's "residual sugar"). No residual sugar? That's a "dry" wine. Some sugar left over? Then it might be "sweet." (The different styles of Riesling* are a great example of how a single varietal can yield a range of wines, from bone dry to very sweet.)

So, this means a wine can taste like fruit even if it's completely dry (meaning, there is no residual sugar). It can also taste like things other than fruit—mineral, herbal, even animal—even if there's sugar left. Fruity isn't necessarily the same as sweet, and savory isn't necessarily the same as dry. (So, yes, a wine can be both sweet and savory.) This is often even more complicated because some allegedly "dry" wines in fact can have quite a bit of sugar left in, like the old, buttery style of California Chardonnay,** or some modern red blends.

Next time you try your favorite wine, think about whether it's dry or sweet, fruity or savory. See where it appears on the chart opposite.

FRUITY

- White Zin
- Zinfandel
- Argentine Malbec
- Viognier
- Cru Beaujolais
- Albariño
- Truly Dry Rosé
- Sauternes
- Most Rosé
- "Oaked" Chardonnay**
- Banyuls
- Most Rhône Whites
- Ice Wine
- Dry Riesling
- Late-Harvest Riesling
- New World Pinot Noir
- Dry Loire Whites*
- Ruby/Vintage Port
- New World Merlot
- Red Burgundy

SWEET — **DRY**

- Off-Dry Riesling
- New World Cabernet
- Red Bordeaux
- Loire Reds
- New World Sauvignon Blanc
- White Burgundy
- Traditional Syrah
- Tawny Port
- Chablis
- Muscadet
- Madeira
- Santorini Whites
- Sherry (dry)

SAVORY

THE NEW WINE RULES

The device known as the waiter's friend is the only corkscrew you'll ever need. It has the right amount of leverage, a foil cutter, and (usually) a silicone or nonmetal screw that more easily goes into and stays in the cork. And it's usually $10 or less.

While they're used all over the place, I can't stand "winged" corkscrews! They are more unstable when handling the bottle and often require more fiddling and more effort to pull the cork. Also, the sides of these screws are often sharp-edged, which can often result in shearing or breaking the cork.

If you're going really pro, you can buy an ah-so, a double-pronged extractor for old and brittle corks. It's inserted on either side of the cork and helps hold the cork together as you pull it out. And if you really want to splurge on a pro tool, the Durand (pictured top right) combines the best aspects of a corkscrew and an ah-so to extract fragile corks intact.

You can have all the corkscrew you need for less than $10.

RULE 8

It's really not hard to open wine like a pro.

* After consuming the first bottle, you may notice these steps become far more fluid (or at least feel like they do).

❶ If possible, place the bottle on a stable surface about waist height. (With some practice, you can also do this while holding the bottle.) Open it at, or near, the table, if you can. People like to watch.

❷ Cut the foil atop the bottle around the top or bottom lip, using a knife or the cutter in the corkscrew.

❸ Insert the screw at a partial angle, which may seem odd, but it's the best way to ensure it goes in properly.

❹ Once you have the corkscrew in, the bottle shouldn't move, only the opener— unless you're opening sparkling wine (see page 28). Turn until the screw is a half-turn short of fully inserted, and bring it upright as you turn.

❺ Place the first lever (if your corkscrew has two) on the bottle lip. Pull up and then place the second lever on the lip . . .

❻ And pull upward until the cork is nearly extracted.

❼ *Gently* remove cork, using your hand if needed.

❽ Twist cork back off the screw. Finally, pour yourself a quick, teensy taste first— just to make sure the wine's okay.

It's even easier to open sparkling wine like a pro.

Never pop out the cork, unless you feel like wasting wine (and, as a bonus, possibly knocking someone's eye out). Instead, untwist and slightly loosen the cage, but leave it on the cork. Then follow these four easy steps:

❶ Hold the cork and cage steady in one hand, and the bottle in the other; grip it from the bottom. (If you want more traction, wrap the bottle—or the cork—in a small towel.)

❷ Twist the *bottle* gently back and forth—go slowly and carefully while holding the cork and cage steady.

③ Keep a bit of downward pressure on the cork as you turn the bottle; let the gas in the bottle push the cork up.

④ Add a bit more downward pressure when the cork is almost out; it should come out with a whisper, not with a pop. A little practice, and this will feel really easy!

These four things will make you a master of pouring wine.

❶ Don't splash the wine into the glass.

❷ Pour it softly, but not timidly.

❸ Stop pouring by midglass. You can always refill (see page 88).

❹ Crucially, give a quick semiturn with your wrist as you tip the bottle back up; it will help prevent dripping. It's not a bad idea to keep a towel or napkin in your other hand to wipe the lip and keep it from dripping. (Sommeliers do this for a reason.)

RULE 11

You only need five essential tools for your wine life.

P. T. Barnum would be blinkered by the universe of "groundbreaking" and useless wine gadgets: mechanized bottle openers, "magic" aerators and "miracle" sticks, instant "aging" devices, even electronic decanters. They're mostly garbage.

If you want to accessorize, in addition to having good wineglasses (see page 98) and a corkscrew (see page 25), consider adding the items listed opposite.

❶ A GOOD RACK FOR DRYING GLASSES

One that fits on your counter. Do *not* put your stemmed wineglasses in the dishwasher. (Although cheaper stemless glasses are no problem.) The stems can break, and the compounds in most dishwashing detergent can leave glasses marked and streaked. (Instead of using the dishwasher, wash them with mild dish soap and a brush, as below.)

❷ A GOOD BRUSH FOR CLEANING GLASSES/ DECANTERS

These are specially designed to gently scrub the insides of glasses. Best to keep your (greasy) sponge away from your stemware.

❸ ONE OF THOSE NEOPRENE HOLDERS

These are essential for carrying wine around town, especially if you bike/take the subway/walk. Better yet, buy a few.

❹ A PROPER CHAMPAGNE STOPPER

The good ones clip or snap onto the bottle neck, and use trapped carbon dioxide gas in the wine to keep it fresh.

❺ A FOIL CUTTER

Use a relatively dull knife if you prefer (I often do), but if you open a fair amount of wine, a foil cutter will make your bottle look a whole lot more appealing on the table.

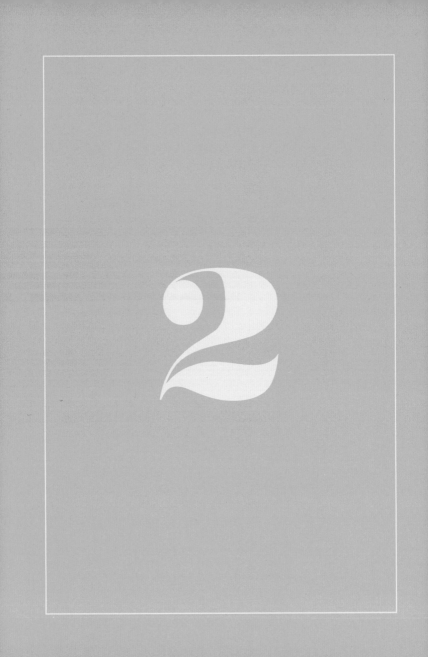

INSIDE THE BOTTLE

Know the shades of white and red and everything in between.

Wine today is so much more than just white and red. There's pink wine, or rosé, which is being taken at least as seriously as white wine (as well it should). There's "orange" or skin-fermented white wine, which, like rosé, falls somewhere in between white and red. There are oxidative wines (see opposite) like sherry and many whites from the Jura region of France, plus some wines made using long exposure to air, in vessels like amphorae. That's why it's important to drink the rainbow—wine in all its many shades (see page 12).

Some quick explanations of what's what:

WHITE

Usually made from white grapes, although red grapes pressed immediately can yield a Blanc de Noirs ("white from black," literally), which can be either sparkling or still. The pressing takes place soon after harvest so as not to take too much pigment or phenols from the grape skins and seeds, although letting the grapes soak with the juice for a little while before they're pressed (aka skin contact) can deepen the flavors and textures.

RED

Made from red grapes, very occasionally with a small bit of white thrown in. Red wine needs to sit on the grape skins to pick up color and structure, and it is usually pressed one to four weeks after the grapes are crushed—although various techniques have complicated this process. For example, in certain wines (often called carbonic or semicarbonic), the grapes begin fermenting without being crushed, as the weight of the grapes on top crushes the ones on the bottom.

ROSÉ

Made from mostly red grapes, either by pressing after a short soak (hence a little pinkish color, but not red) or by bleeding away (*saignée*) some lightly colored juice from a tank of red-grape juice, then fermenting it. Rarely but occasionally made by blending white and red.

"ORANGE"

Wine from white grapes that's made like a red—soaked on the skins for weeks or even months to gain texture and a deeper color. This process can be oxidative (see below) but doesn't have to be.

OXIDATIVE

Wine made with some exposure to oxygen. This *does not* mean it is oxidized (see page 54), often just the opposite. Exposure to air, especially before fermentation, can help to bulletproof the wine against the spoilage of oxygen. So can a related technique known as biological aging.* Some sherries, and many wines made in old-fashioned vessels like clay amphorae, incorporate oxidative aging.

SPARKLING

Wine with bubbles. See page 36.

* "Biological" aging involves formation of a protective yeast "veil" on top of the aging wine. Fino sherry and some Jura wines are made this way.

RULE 13

Not all sparkling wines are created alike.

There are lots of ways that bubbles can end up in wine. Not all produce wines of the same quality—nor do they need to—but it's worth understanding the significant methods, so you know why, say, Prosecco is usually way different from Cava.

A note on pressure:
Not all sparkling wine is equally fizzy; the amount of CO_2 (typically more CO_2 = more fizz) can vary widely. Champagne typically is 5 to 6 atmospheres (or bars; 1 bar is about 14.7 psi, or sea-level pressure), although many today are less fizzy than that, to better showcase the flavors. Prosecco is often less; "frizzante" (or *pétillant*) might be up to 2.5 bars, and, above that, it might become "Spumante" or "mousseux."

A note on sugar:
Most sparkling wines come with a bit of sugar, or "dosage," added to soften them. That's why Champagne is often marked "brut," which legally (at least in Europe) means 12 grams of sugar per liter of wine, although there's wiggle room. "Extra brut" is 6 grams of sugar or less, and "brut nature" means no sugar added. And (confusingly) "extra dry," "dry," "demi-sec," and "doux" indicate increasingly *sweeter* wines. Most U.S. wineries follow these guidelines, although there are no official labeling rules.

CHAMPAGNE (OR "TRADITIONAL") METHOD

Used in you-know-where, and in many wine regions around the world. Bottles are filled with a still "base" wine, then sugar and yeast are added which allows a second fermentation to occur in the bottle, which creates the bubbles. Extended aging—at least fifteen months in Champagne, and often far longer—allows for fine bubbles and adds richness to the wine. Most Cava is also made this way. The process typically finishes with disgorgement—the act of removing any leftover yeast, sometimes adding a bit of sugar, and putting a cork into the bottle.

CHARMAT (OR TANK) METHOD

The base wine is put in a big tank, to which the yeast and sugar are added. The second fermentation occurs in the tank, after which the wine is bottled. Used in less fancy wines, including most Prosecco.

CARBONATION

CO_2 gas added to still wine in a pressurized tank. For relatively cheap wines (plus a handful of avant-garde projects, like the California wine called Blowout).

ANCESTRAL METHOD/PÉTILLANT-NATUREL

Rather than two fermentations, as with Champagne, this method involves putting wine in bottles while it's still fermenting (or during a pause in fermentation) so the CO_2 bubbles are generated from the same fermentation. This allows the use of indigenous yeast (naturally found in the vineyard and winery, versus commercially sold yeast that can be added to grape juice). Prior to the arrival of *pét-nats*, this old method was practiced in places like Limoux and Bugey, in France.*

* There's debate about what constitutes a *pét-nat*, since some modern versions of the ancestral method rely on disgorging and even added yeast. Some purists insist that *pét-nat* wines must not be disgorged. But this seems like splitting hairs.

"Made from organic grapes" means exactly that: the grapes were farmed organically, which typically requires a certification. (Many winemakers, however, use organic but uncertified grapes—their grapes are farmed using organic practices, but they do not go through the process of certification.) Organic wine isn't the same thing as organic grapes: an organic wine certification also covers cellar practices, notably almost zero use of sulfur dioxide as a preservative. Biodynamic farming is even more particular in its requirements and can be certified by organizations like Demeter and Biodyvin, although a growing number of winemakers use biodynamic practices but eschew certification. Certified biodynamic wines are governed by strict rules in the cellar—for example, no use of technical methods to reduce alcohol levels. "Sustainable" doesn't mean a whole lot, although it can in a few cases; Groups like the Salmon Safe environmental coalition ask members to adhere to rigid sustainability practices. Natural is a more complicated term (see page 41). "Natural wine," which has no rigid definition, has become a popular category. Generally, adherents try to minimize additions and processing during winemaking, but that means different things to different people. As with food products, "natural" has little regulatory meaning in the United States.

Organic and biodynamic mean something specific. Natural means a different thing.

"Malolactic" sounds like the most complicated of wine terms. But it's really simple.

Often you'll hear wine types talk about *malolactic fermentation*—"conversion" is a more accurate term—or simply "malo" or "ML." This is when a wine's malic acid (think green-apple tartness) is converted to more stable lactic acid (think yogurt) via bacteria that occur naturally but which can also be added by winemakers.

Often malo is used to describe a more creamy, rich texture in white wines and can indicate rich, buttery aromas—and it's true that wines undergoing ML can be creamier. But it is also a natural process for most red wines and many whites. (A few white grapes, like Riesling, are less prone to malolactic fermentation.)

There used to be a belief that ML could make white wines, especially Chardonnay, too rounded and soft. Winemakers would block the conversion in order to keep the wines fresher and more acidic. (This usually meant they had to filter the wine to keep it stable.) But today there are no firm rules. A Chardonnay that undergoes ML can taste more acidic than ones that don't.

So yes, the term often indicates a sense of relative richness in the wine. But other types of acid (like tartaric acid, which is far more stable) can make a bigger difference in a wine's taste and texture. This is where it's wise not to conflate chemistry with taste.

Most wine is natural, in the sense that it's fermented grape juice, with no artificial flavorings or colorings.

But from there, things get complicated. The idea that wine is simply the result of crushing grapes and fermenting the juice is archaic—and quaint. The modern winemaking process involves fine-tuning and often modifying the chemistry of wine in ways that can be artisan but are often industrial.

This might involve tweaking the acidity in wine by adding organic acids that might or might not occur naturally in wine (citric acid? Not really in grapes), as well as adding commercially harvested yeasts, yeast nutrients, and enzymes to help fermentation. The preservative sulfur dioxide is a routine part of winemaking (see page 44). And the U.S. government allows dozens of other additives, from gum arabic to soy flour.

For that matter, the process of aging wine is a manipulative process. Barrels, steel tanks, and so on are all technological advancements, no different than cooking on a stove instead of a campfire.

And wine is routinely processed before bottling, including *fining* (removing small particles by passing things like powdered

Most wine is natural. Most wine is also not "natural."

clay through the wine) and filtering. Both used to have a bad reputation for stripping character from wine, but neither inherently ruins wine quality; in fact, some wines, including sherry and many whites that don't get malolactic conversion (see page 40), require a light filtration.

It's precisely because of these processes, and scrutiny of them, that the natural-wine movement has emerged. "Natural wine" has no standard definition, but generally defines wine that has avoided many of these processes. But even naturalists don't agree on the exact rules.

Finally, there's often interest in whether wines are vegan. Many animal products are used in producing wine (sturgeon bladders or eggs for fining, for instance), although vegan-conscious winemakers try to avoid them and a "vegan" wine will have been made without them. But even then (sorry!) insects and other small animals can wind up in grape bins and, yes, crushed into the grape must. Like I said, it's complicated.

WINEMAKING STYLES

Hardcore "Natural" **Relative Purist** Moderate Commercial **Industrial**

WINEMAKING STAGES

BEFORE FERMENTATION	FERMENTATION	AGING

BEFORE FERMENTATION

Destemming

"Cold Soaks"

"Bleeding" Juice

Acid Additions

Sulfur Dioxide (Crush)

Water/Sugar Additions

Lysozyme/ Antimicrobials

FERMENTATION

Barrel Fermentation

Indigenous Yeast

Commercial Yeast

Carbonic Maceration

Skin Fermentation

Whole-Cluster Fermentation

Enzyme Additions

Temperature Control

AGING

Texture Additives

Oak Chips/Tannin Powder

Blocking Malolactic

Natural Malolactic

Micro-Oxygenization

Blending

FINISHING

Spinning Cone

Crossflow Filtering

Bottling

Disgorgement (Sparkling)

Sulfur Dioxide (Bottling)

PRE-BOTTLING

Megapurple

Velcorin

Fining

Basic Filtering

Reverse Osmosis

Racking

Stop worrying about sulfites.

"Contains sulfites" is on nearly every bottle of wine, because they're naturally occurring substances in wine, often a by-product of the winemaking process. Historically, small amounts of sulfur dioxide have been added to help prevent grapes or wine from oxidizing and spoiling. And by "historically," I mean going back to Roman times, when sulfur wicks were burned to sanitize wine vessels.

Sulfites have often been fingered as a culprit for headaches and adverse health effects from drinking wine. But *very* few people, around 1 percent of the U.S. population, have true allergies or sensitivity to sulfites. Most adverse effects from drinking wine— like those headaches—come from other things: a histamine reaction, for instance, or migraine sensitivity, or (obviously) the presence of alcohol. What you might think is a sulfite problem probably isn't. (If you're sulfur sensitive, dried fruit, bottled juices, condiments like wine vinegar, many pickles, and powdered tea would also be troublesome.)

A number of winemakers work with unsulfured, or *sans soufre*, wines. Those wines often are of good quality, but there's little beyond anecdotal claims to demonstrate that they differ in their effects on drinkers. (The use of sulfur dioxide in grape farming and

wineries, however, does seem to have potential health impacts on winemakers, and requires careful handling. This explains why many winemakers want to use less of it.) Another myth: European wines don't have fewer sulfites than New World wines—although European Union regulations do generally have lower limits than the United States.

Or if your wine is a bit cloudy. The crystals are tartaric acid, which naturally occurs in all wine and can precipitate when the wine is quickly chilled. They're harmless, not unlike the granules on Sour Patch Kids (and are essentially the same thing as cream of tartar). And cloudiness can occur in unfiltered wines that aren't cold stabilized; it's a sign the wine has been minimally handled before bottling. (Some natural wines can be distinctly cloudy; this might be unsettling at first but doesn't necessarily say anything about quality.)

Don't worry about those little crystals at the bottom of the bottle.

Dry wine isn't as dry as you think it is.

"Dry" is one of the most misused terms in wine. Everyone believes they prefer dry wine, even if they really enjoy a bit of sweetness.

A lot of table wine, especially from Europe, is categorically dry (meaning there is no residual sugar; see page 22). But many popular wines have a bit of hidden sugar, often cloaked by elevated levels of acidity. (This both revitalizes your sense of taste and surreptitiously indulges your sweet tooth.) In supermarket wines, especially, there's a tendency to keep sneaking in more sugar. You might think of it like clothing sizes; what was an 8 a decade ago is a 6 today.

The style of Chardonnay made popular in California in the 1980s relied on some leftover, or residual, sugar. New Zealand Sauvignon Blanc often does something similar. One popular Napa Cabernet has 9 grams per liter of sugar, enough that it would be considered off-dry under German wine law.

Sugar and acidity directly counterbalance one another, which is why places like Germany and Austria define their dryness levels in relation to both things. What really matters is how the sweetness in the wine plays off its other aspects—acidity, texture, savoriness.

In the meantime, don't worry about insisting your wine be dry.

Oak is a controversial topic in wine. Connoisseurs complain some wines are too oaky (meaning they detect the flavor of oak or coarse tannins sometimes extracted from wood), but some drinkers enjoy the sweet vanillin flavor associated with aging in wood.*

Here's the thing: Prior to widespread bottling technology, oak barrels were mostly used as shipping containers to send wine to market. Barrels were often (and still are) reused because wineries couldn't afford to buy new ones. Only when winemakers, in Bordeaux and elsewhere, concluded that wine tasted better when aged in new, often toasted barrels did buying them become a regular habit. And when critics rewarded wines for the taste of new oak (each time a barrel is reused, the oak contributes less and less flavor to the finished wine), buying new barrels became widespread. But the number of wines that benefit from new oak is small, and many of the best wineries today use lightly toasted barrels, or older ones, to minimize the flavor.

In fact, today it's increasingly fashionable to focus on the flavors of the *wine*, not the wood, although many wineries, especially those making cheap wine, use oak chips and sawdust to add oak flavor. That should be a tip-off to the essential thing to remember: an oaky wine is a flavored wine.

RULE 20

Don't get too fixated on oak in wine. Its original purpose was for storage, not flavor.

* There's frequently debate about the *type* of oak, too, especially whether French or American. The first is often associated with high-class wine and the second with more aggressive and astringent flavors. It's never that simple, of course, especially as other oaks (Slavonian, Austrian) become more popular, and as winemakers desire less taste of oak.

CASK → Large wooden vessel, usually made of oak or chestnut, historically used for aging in cellars. Often still preferred for traditional winemaking.

CONCRETE "EGG" → A modern twist on the traditional use of concrete for fermentation and aging that allows the wine to circulate more easily. Now being made in other shapes, like cylinders and pyramids.

AMPHORA → An ancient clay vessel originally used for transport and storage. Similar vessels (sometimes called *qvevri*) were used for fermentation, and in varying shapes these are newly fashionable for fermentation and aging.

BARREL → A smaller vessel, usually of oak, originally intended for transport but now typically used to age wines.

Acidity might be the most important quality in wine.

We often get hung up on wine's flavors. They are important but can be nonspecific: how many wines have you had that tasted of red cherries? They also distract from one of the most essential components in wine: acidity. (Winemakers spend a lot of time worrying about acidity; if there's too little, they may add some artificially.)

Acidity is what makes a wine lively and enjoyable; it's what makes our mouths water when we drink, and it's why wine goes so well with food (it helps cleanse our palates and aids digestion). A good wine won't taste sharp but will have enough acidity to help make food more appetizing. It complements what should be a good use of acid in cooking. (Think vinegar, ketchup, lemon, and so on.)

Perceiving acidity in wine can be tricky, because acidity *accentuates* all the things we taste. If it's in balance, it will heighten flavors without sticking out—just like the (very high levels of) acid in orange juice or Coca-Cola, which rarely taste tart. Often a bit of sugar in wine helps balance out the acidity; this is why off-dry (slightly sweet) German Riesling can taste more fruity than distinctly sweet (see page 22). Even hearty reds like Zinfandel need good acidity, enough to keep big fruit flavors tasting fresh.

A wine can be fruity or savory, but how does it feel in your mouth when you taste it? Is it creamy (a sign it might have undergone malolactic fermentation, see page 40), or is it sharp? If it has tannins, are they subtle or are they aggressive and scraping in your mouth, like oversteeped tea? This is why words like "smooth" don't really tell us much about a wine—aside from the absence of too much of any one aspect. And be mindful that a wine's *density*—how concentrated the flavors and other aspects are—isn't the same as texture. A wine can be creamy, but also watery.

RULE 22

Texture might be the second most important quality in wine.

We tend to think of wine as a consistent product, but over and over again, it's been shown that bottles can vary, even if it's the same vintage and wine. Bottle variation has lots of causes: exposure to heat and light during storage, cork quality (not necessarily uniform even in the same bottling), and even how the wine is transported. And because wine is often living—it evolves and matures in the bottle—the wine itself might react differently even in similar conditions. Better corks and transport have made this less of an issue than in the past, but don't be surprised if you order a second bottle, and it's a bit different.

RULE 23

No two bottles of wine—even of the same wine—are exactly alike.

Don't fear sweetness. (Really!)

* These are among the wines often affected by the welcome mold known as *botrytis*, which shrivels grapes and concentrates both acidity and sweetness.

** Historically, some wines, especially French, were subject to *chaptalization*, or the routine adding of sugar at fermentation to boost alcohol levels. One unintended consequence of climate change is that many winemakers do this less frequently, as grapes today are often riper than in the past.

It may be associated with things like cheap White Zinfandel, but the last thing I'd want is for you to think that sweetness in wine is *bad*. Some of the world's greatest wines are sweet, including Sauternes and late-harvest German Rieslings.*

We drink plenty of other sugary things—apple juice, sweet tea, soda—and wine at least has the benefit of its sugar being a part of the natural product (theoretically**). It's all a question of balance and of your own taste.

The real question is *when* to drink a sweet wine, and even for wine lovers the answer is usually not often. Bottles of dessert wine often get unintentionally aged because we *never* find a moment to drink them. It's actually not that interesting to serve a dessert wine with dessert, unless it's something light and brisk like a Moscato d'Asti. But good Sauternes can be served with lobster and even red meat, if the wine isn't too young or too sweet. Off-dry Riesling is wonderful with all manner of food, including barbecue and pizza. And there's nothing wrong with making wine your dessert course. In fact, there's nothing wrong with drinking sweet wine whenever you like.

We all encounter a faulty wine now and then—one that doesn't smell or taste quite right. You don't need to be an expert on faulty wines, and none are harmful to you, but it's worth understanding the common causes listed on pages 54 and 55.

First, most wine is very well made—far better than it was twenty-five years ago—but even with a modern understanding of science, wine still faces old-fashioned shortfalls.

Most pros don't waste time dwelling on faults, unless they're being passed off as "character." The best way to approach telling a store clerk or waiter about possible faults is to be polite and questioning. Some faults are enough cause to ask that the bottle be replaced; others are a bit more buyer-beware.

If you want to learn to identify faults, try asking a retailer or restaurateur you know to help you identify some basic flaws. Often they'll have a faulty bottle around waiting to be sent back. (Generally, they're reimbursed for most faulty bottles.) If you really want to learn, you can buy a kit from the Le Nez du Vin aroma series.

Most of all, one key rule: *speak up* as soon as you think something's wrong. The customer who tries to bring back or send back a half-finished bottle is the customer who doesn't get welcomed back.

The occasional faulty bottle of wine is a fact of life. Don't let one ruin your day.

"CORKED" WINE

A condition when the wine is tainted by *TCA* or *TBA*, compounds related to chlorine and bromine. These compounds appear in cork bark and can be formed in the presence of certain cleaning products. Mostly this happens because of the cork (although cork makers have been vigilant in reducing the problem). In rare cases, it can happen in the winery itself.

→ SYMPTOMS **The wine smells and tastes like wet cardboard, or a wet dog, or a damp cave.**

COOKED

Occurs when a wine has been exposed to excessive temperatures and loses its freshness. A few wines, notably Madeira, are deliberately made this way, which is why wines impacted this way are often called "maderized."

→ SYMPTOMS **Smells and tastes stale, like old raisins or dried fruit.**

OXIDIZED

When a wine is exposed to too much oxygen.

→ SYMPTOMS **A rusty or "tired" taste; bottles left open or aged too long often taste this way.**

BRETTANOMYCES (BRETT)

A type of naturally occurring yeast that can be used to good effect in some beers, but is generally unpleasant in wine—although some drinkers like small amounts. You can't really send back a wine for being distinctly bretty, but you can certainly question the judgment of whoever sold it to you.

→ SYMPTOMS **Smells and tastes like a barnyard, Band-Aids, or like the less pleasant parts of a horse.**

REDUCTION

When a wine, usually from a lack of oxygen during winemaking, retains sulfur compounds that impact the smell and taste. Some reduction is natural (a lack of oxygen protects wine) and can blow off with air and time, which is often what we mean when we talk about a wine "opening." Sometimes the compounds are *bound*, which means they won't really go away.

→ SYMPTOMS **A smell like sewage, onions, rotten eggs, or struck matches—anything you'd associate with sulfur.**

MOUSINESS

A distinct flavor, often caused by compounds generated by the presence of lactobacillus or brettanomyces that can subdue a wine's proper taste. It seems to show up most frequently in unsulfured wines, especially those bottled early; there's no direct correlation as yet, but that explains why it's a frequent topic of discussion in the natural-wine community.

→ SYMPTOMS **Often described as "mouse cage," it can taste like wet crackers, stale tortillas, or cornflakes. Often it will show up in a wine's aftertaste.**

LIGHT STRIKE

Occurs when wine in clear bottles is impacted by either sunlight or artificial light (blue or ultraviolet on the spectrum), which generates such compounds as dimethyl disulphide. Especially prevalent in rosé and sparkling wine. Still not commonly discussed, although the industry is beginning to recognize it as a big problem—and encouraging fewer clear bottles and more dark storage. (In general, store your wine in dark places.)

→ SYMPTOMS **Tastes of garlic skins, sewage, cooked cabbage. If a bottle of rosé tastes particularly stinky, light strike is likely the cause.**

OTHER FAULTS INCLUDE . . .

Volatile acidity (vinegar-like flavors), ethyl acetate (nail polish remover), bottle shock (suppressed flavors), and bacterial spoilage (baby poo and other unpleasant flavors).

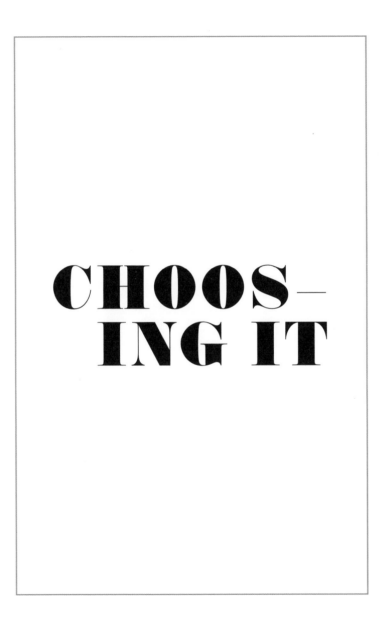

CHOOS—ING IT

A wine's price rarely reflects its quality.

Wine is almost never priced for the exact value of what's in the bottle. A lot of opaque economics—from the cost of vineyard land to a region's reputation—get in the way. And, of course, fair value is in the eye of the drinker.

There are wines that overdeliver (from places like Australia, Chile, the unknown properties of Bordeaux) and wines whose prices have outpaced whatever they can offer (California "cult" wines, some top Burgundies, and so on). Obviously, we all want to be on the first half of that equation, but there are times when spending dearly makes sense.

A FEW THINGS TO KEEP IN MIND

→ It's hard to find wines under $15 that are distinctive and made with care; it's even harder under $10, a category in which most wines are made by big corporations. But it's easy under $20.

→ Few places in the world can justify a wine over $100. They're only worth buying if you do your homework first (and that doesn't mean just checking wine scores).

→ The best values often come from places that have fallen out of fashion. Friends may question you, but once the bottle's open, your smart taste will be evident (see page 77).

Since there are literally thousands of wine grape varieties in the world, it's important to have some way to classify them. This can become a complex task (the family trees of grapevine cultivars can be a genealogical rabbit hole), but listed on pages 60 and 61 are some of the major families you'll want to know and the most significant family members.* Consider this list as a way to start easily organizing the world.

RULE 27

Grapes come in families. Here are some important ones.

* There are also many smaller families, like the Jura (Savagnin, Trousseau, Poulsard) and Port (Touriga Nacional, Tinta Roriz [aka Tempranillo]). As you might conclude, family politics are as complicated for wine grapes as for people!

BORDEAUX

Cabernet Sauvignon, Merlot, Cabernet Franc, Malbec, Petit Verdot, Sauvignon Blanc, Semillon, Muscadelle.

BURGUNDY

Pinot Noir, Chardonnay, Gamay Noir, Aligoté, Pinot Gris, Pinot Blanc.

RHÔNE AND SOUTHERN FRANCE

Syrah, Grenache, Mourvèdre, Marsanne, Roussanne, Viognier, Grenache Blanc, Counoise, Vermentino, Muscat, Carignan, Clairette, Picpoul.

LOIRE

Chenin Blanc, Melon (i.e., Muscadet), Grolleau, Cabernet Franc, Côt.

ITALY (NORTH)

Italy has hundreds of indigenous varieties, with well over five hundred documented. Some essential ones from the North include Nebbiolo, Sangiovese, Corvina, Lagrein, Ribolla Gialla, Sauvignon Blanc, Pinot Grigio, Cortese, Vermentino, Garganega (i.e., Soave), Moscato, Lambrusco (many subvarieties), Barbera, Dolcetto, Glera (i.e., Prosecco), Schiava.

ITALY (SOUTH)

Nero d'Avola, Montepulciano, Aglianico, Falanghina, Fiano, Greco, Primitivo, Trebbiano, Nerello Mascalese (i.e., Etna), Cannonau.

TEUTONIC

Riesling, Gewürztraminer, Grüner Veltliner, Blaufränkisch, Zweigelt, Trollinger, Chasselas, Sylvaner.

IBERIAN

Tempranillo, Albariño, Mencia, Cariñena, Mataro (aka Monastrell), Touriga Nacional, Garnacha, Palomino, Macabeo and Xarel-lo (i.e., Cava), Hondarrabi Zuri (i.e., Txakoli), Verdelho, Godello, Baga, Boal, Loureiro, Moscatel, Pedro Ximénez.

CENTRAL/EASTERN EUROPE

Assyrtiko (Greece), Xinomavro (Greece), Furmint (Hungary), Plavac Mali (Croatia), Posip (Croatia), Rkatsiteli (Georgia), Saperavi (Georgia), and many others.

NEW WORLD

Very few grapes aside from South Africa's Pinotage have a distinctly New World bearing, although some (like Malbec in Argentina) are more identified with their adopted home. Zinfandel (originally a Croatian grape called Tribidrag) and Shiraz (aka Syrah) are two that effectively crafted new identities.

If this seems tilted toward western Europe, especially France, that's because nearly all the fine-wine grapes grown around the world today originated there—so that Cabernet, as Californian as it may feel, is still originally an immigrant from Bordeaux. That doesn't make it less Californian; it's just a way of understanding its roots.

In some cases, multiple regions claim "ownership" of the same varieties. Often a style of wine varies based on the origin—or the original inspiration. In California, for instance, you can find Cabernet Franc inspired both by the Loire and Bordeaux (and also versions that are sui generis). Furthermore, many varieties go by different names in different regions. Here are a few examples of the many synonyms that exist in the world:

Zinfandel = Primitivo

Malbec = Côt

Trollinger = Schiava

Pinot Gris = Pinot Grigio

Grenache = Garnacha = Cannonau

Muscat = Moscato = Moscatel

Mourvèdre = Mataro = Monastrell

Carignan = Cariñena

Appellations are about much more than where a wine is made.

Wine people like to talk about *appellations*, which are specific government-regulated areas where wine grapes are grown. Only a wine from grapes grown inside an appellation can use the appellation's name (for example, Vosne-Romanée, Oakville) on its label. That's different from the location where a wine is made, which doesn't have to be in a location inside an appellation; it could even be in a city warehouse, which is how "urban wineries" have become a reality.

Some wines are labeled with locations, like "Bordeaux" or "Central Coast," that don't necessarily describe a single place. A single wine marked "California" could come from grapes grown in one place, or twenty!

In the case of European wines, appellations also can dictate how a wine is made. And some winemakers choose to leave an appellation off their label. Many French natural wines are marked simply "Vin de France" because the winemakers don't follow appellation rules. Other appellations, like Bourgogne Passetoutgrains (a mix of Pinot and Gamay) specify the type of wine but cover a large geographic area.

In other words, true European appellations are a specific way of making wine—not only the types of grapes (the grape Chenin

Blanc is used in the Savennières appellation, Syrah in Côte-Rôtie) but often the methods of farming, yields, and exact geographic boundaries, too. Appellations are more than a mere location. American "appellations" (technically known as American Viticultural Areas or AVAs) specify geography, like the Sonoma Coast, but nothing else; this is why they're not technically appellations in the Old World sense.

For this reason, it's easiest to decipher Old World labels primarily by appellation and New World primarily by grape—usually. In France, it's rare (although ever less so) to find a grape name on a label, so you'll want to know that Chablis is always made from Chardonnay (or at least you'll want to know what Chablis tastes like). For the New World, you'll probably start with the grape, and then look at the place (Pinot Noir from Oregon).

Of course, nothing is quite that simple. Many Old World regions have hybridized their approach, as in Germany, where grapes still appear (e.g., Riesling) even though their system of place-names (e.g., Wehlener Sonnenuhr—the Sonnenuhr vineyard in the town of Wehlen) is one of the world's most exacting.

Morgon 2008

Appellation Morgon Contrôlée

"*Côte du Py*"

Mis en Bouteille par
Foillard, 69910 Villié-Morgon
Product of France

Vin de France

Parsing wine labels was never easy; the rules for New World wines (usually denoted by grape) were different from the Old World. And in Europe, French and Italian wines (usually based on appellation) were different from, say, German (based on region, vineyard, and grape).

And all that was before the current label fashion of putting dramatic art and graphics over the boring old particulars. The old rules still hold true for wines that put the basics in small type, but in France alone, for instance, there are hundreds of wines that ditched appellations for simple "vin de France," plus fanciful names— from the subtle ("Le Berceau des Fées," or "Cradle of the Fairies") to the stark ("You Fuck My Wine?!").

Today, then, it's as important to know producers and their work as to memorize appellations, because choosing wine has become as much a fashion statement as anything. And if I'm being honest, it probably always was.

The old ways to judge a wine by its label don't really work anymore.

Be wary of wines that aren't clear about exactly where they come from.

The reason for all that nitpicking about places and appellations is that place—*terroir,* or "somewhereness," to borrow a fellow writer's term—is the major reason why wine is so fussed over. Place matters. And there are many would-be "appellations" that tell you very little; the "Central Coast" of California encompasses hundreds of miles, which is fine for a cheap everyday wine but not if you're paying for something unique.

Keep a close eye on place-names that don't match up neatly with real spots on the map. "Sonoma Coast" can apply to fantastic Pinot Noir, but it encompasses half of Sonoma County. The less specific the place, the more likely the wine was assembled, not grown in one particular spot—which is to say, more likely that it's the wine equivalent of fast food.

Once upon a time "estate bottled" indicated a wine made by the people who grew it. But with a few exceptions, it no longer means that much—especially in a world where many of the best winemakers can't afford their own vineyards. This is true not just in places like California but even in Burgundy, where top winemakers have to buy grapes. (The term *domaine* is essentially the equivalent of "estate bottled" there; *maison* is the alternative for *négociant* wineries that buy grapes or finished wine.) And many great winemakers choose to work in cities, far from their vineyards. What really matters is where the grapes are grown (see page 62), not where they ferment.

RULE 31

Ignore "estate bottled."

RULE 32

The world of wine is ever expanding.

In the 1950s and 1960s, wine was relatively easy to understand: it came from famous places like Bordeaux, Burgundy, and Chianti. But tastes and fashions change, and as the techniques of good winemaking spread to ever more regions the wine world has exploded with diversity.

These dates aren't when the regions were *discovered*, necessarily, so much as when they became well known.

1960s

1970s

1980s

1990s

2000s

TODAY

Bordeaux, Burgundy and Chablis, Classic Loire*
(Muscadet, Sancerre, Pouilly-Fumé, Anjou, Chinon/
Bourgeuil), Germany, Port, Madeira, Jerez, Rioja,
Champagne, Châteauneuf du Pape,* Chianti,*
Alsace, Frascati

California (North Coast and Sierra Foothills),
Portugal, Provence, Tuscany,* Piedmont (Barolo,
Barbaresco, Barbera), Beaujolais, Lambrusco,
Soave, and Orvieto

Oregon, California (Central Coast), Northern
Rhône,* Tuscany, Soave, the Veneto and
northeastern Italy, Ribera del Duero, Rueda,
Vinho Verde

Argentina, Chile, Australia, Greece, Washington,
southern Rhône,* South Africa (post-apartheid),
New Zealand, northern Italy, Portugal (dry wines),
Languedoc, and Roussillon

Austria, Liguria, Priorat and regional Spain, Sicily
and southern Italy, Canary Islands, Slovenia,
Lebanon, Jura,* Savoie

Georgia, "New" Australia, Galicia, Corsica,
Arizona, Canada, Croatia, "New" Germany
(Baden, Württemberg, etc.), "New" Loire,
Japan, and beyond

*Not all regions
were unknown
before they became
popular, and not all
have maintained
their popularity. The
northern Rhône was
known for its wine
decades before it
was popularized in
the 1980s, as was
Corsica, but the wines
remained hard to
find. In the meantime,
German wine, a major
force in the first half of
the twentieth century,
struggled to maintain
its popularity as the
wine world diversified.
The same has been
true of Châteauneuf
more recently.

Know what *Grand Cru* means— and when it matters.

Grand Cru is one of the most revered—and often confusing—wine terms. It literally means "great growth," and it's meant to denote the most important vineyards and wines. But the term is more complicated than that, because it means different things in different places.

Premier Cru, or "first growth," can be even more confusing; it usually indicates higher-quality wine that's one step down from *Grand Cru*, but can mean other things (especially in Bordeaux). Here's what the terminology means in different regions:

BURGUNDY

One place where the definition of *Grand Cru* is (almost) beyond question. It signifies the top vineyards, as ordained by appellation rules and takes only vineyard quality into account, regardless of winemaker or winery. While it isn't perfect, the hierarchy was refined over hundreds of years. It means the same thing in Chablis, Burgundy's northern annex.

ALSACE

Here *Grand Cru* is meant to denote the best vineyards, but "best" is complicated in Alsace, especially with fifty-one *Grands Crus* (versus just over thirty in Burgundy). Some Alsace *Grand Cru* wines are decidedly better than the region's other wines, but not all. What's for sure? They'll be more expensive.

BORDEAUX

Crus here represent wineries, not specific places or terroir, although the Bordelais might claim the two are the same. The famous 1855 classification system is somewhat the reverse of Burgundy: only the top few wines of the region's Left Bank are considered *Premiers Crus*, while all five levels of the classification are considered *Grands Crus*. (Some first-growth wines, like Château Margaux, are labeled *Premier Grand Cru Classé*.) Then on the Right Bank, in Saint-Émilion, the top wineries are designated *Premier Grand Cru Classé A* (there's also a *Classé B*), while *Grand Cru* is actually a relatively modest rank. Sound confusing? It is, because classification in Bordeaux is a ridiculous business. (That's probably why someone is always suing someone else.)

CHAMPAGNE

Here *Grand Cru* denotes grapes from villages given top-quality status, but the status was originally based on the price of each village's grapes. It's still used on a town-by-town basis, rather than vineyard by vineyard, which is as imprecise as it sounds.

GERMANY

The German version of *Grand Cru*, "Grosses Gewächs," denotes wines from what in the 2000s were chosen as the best vineyards—but until recently the wines could only be made in a certain way (very dry) and for the most part only from Riesling. Also, not everyone participates in this scheme. So, some of the best German wines aren't necessarily labeled this way.

ITALY

Has thus far generally avoided the whole thing, although the Italians are always threatening to create such a system. (They have a different set of terms for wine quality, like *Superiore*, *Classico*, and *Classico Superiore*, that is equally confounding.)

NEW WORLD

None so far, although there is always talk of creating them, especially in Napa Valley. One California winery was misguided enough to put California *Grand Cru* on its labels, but it quickly stopped after being roundly mocked.

Learn the importers of your favorite wines. Understand the difference between importer and distributor.

There's a long path in the United States from a foreign vineyard to your glass. An *importer* selects wine (sometimes with the help of an agent) and arranges for it to be brought into the country. The importer's name is legally required to appear on the back label. A *distributor* is responsible for buying wine from U.S. wineries and importers (although some might import wine themselves, too) and selling to restaurants and stores. The distributor's name usually won't be listed anywhere.

Learning about great importers is one of the best ways to discover top-quality wines, especially as consolidation in the wine industry has made it harder to know whether a wine came from a corporation or a small winery. Small importers and smaller shops tend to specialize in human-scale wineries, so learn to find a few you appreciate. (Kermit Lynch, Louis/Dressner and Terry Theise are some of the classic names found on imported bottles. Selection Massale, Avant-Garde, Grand Cru, and The Source are promising new ones. Some, like Jenny & François, specialize in natural wines.)

Most wine stores will give at least a small discount if you buy twelve bottles or more. But don't just buy twelve bottles of the same thing! Use the opportunity to build a sampler that lets you explore. Better yet, get them to help you assemble one, along the lines of a theme (spring whites, reds for the beach, esoteric grapes from Italy, and so on). Most good wine shops will jump at the chance to help out with this.

Want to buy by the case? Buy a mixed case.

White wine is often the best value on the shelf.

White wine has a bad rep of being simple. I'm not sure where it comes from, but don't believe it.

For one thing, some of the best wines in the world are made from white grapes: Burgundy's Montrachet, for instance. And some are remarkable values, like the wines of Germany's Mosel or Santorini in Greece, even white Bordeaux. That often makes whites a much better quality for the money, and easier to explore because they tend to be less expensive.

If white winemaking was once overly simple, today winemakers take it very seriously. And modern whites have as broad a range of textures and flavors as reds. Plus, most white grapes cost less for wineries and are easier to handle, so you get more value for your dollar. Also, because no one bothers to learn about white wine, you'll quickly become the expert at the table.

White Zinfandel. Merlot. Pinot Grigio. Muscadet. Prosecco. Lambrusco. Most versions are low grade, boring, industrial.

Except that each has people again treating them with great respect. White Zin once was a serious rosé; a handful of Californians are treating it that way again. Merlot got a bad rap in the early 2000s, not wrongly so, but it's responsible for many of the best wines on Bordeaux's Right Bank, including the legendary Château Pétrus. The best Pinot Grigios from northern Italy and Slovenia have all the depth of great Burgundy. There's Prosecco, being made today not only for the all-you-can-drink brunch but as diligently as Champagne. And so on.

RULE 37

Here are some wines you can probably forget about. (Except, not.)

Anyone can start a wine collection for under $300.

Wine collecting is not for snobs, and it doesn't have to be hard. Choose a few bottles you'd like to try sometime after next week. Buy several bottles of the same wine to try over a few years, or buy a mixed case of ageable wines from different places. The trick to doing it affordably is not only to look to some less-familiar places but also to choose more modest wines from regions with a reputation for age-worthy wine.

Keep an eye out for these wines: Langhe Nebbiolo and Gattinara from Piedmont, which are less expensive than their Barolo big brothers; outer-banks Bordeaux from spots like Fronsac and Bourg; Cabernet Franc and Chenin Blanc from the Loire; Carignan and more nuanced Zinfandels from California; Chablis and less-known Burgundy appellations like Fixin; Fiano from southern Italy; reds and whites from up-and-coming regions like Sicily's Etna and Spain's Ribeira Sacra. And some places like Germany continue to overdeliver; you can buy many of the world's top Rieslings for under $35. Just make sure you have somewhere to store your bottles (see page 102).

Wine *is* fashion, and fashion can be fickle. Some wines—remember Merlot?—have stretches of being uncool, and often that is the best time to discover them. They're often cheap, and the worse versions tend to vanish from shelves. (The upside to hating Merlot was that Merlot got much better.)

A short list of places worth exploring now: smaller producers in Australia; Chile; warmer California regions like Lodi; Chianti; Rioja; Muscadet. And grapes: Merlot, Semillon, Sangiovese, Viognier, Grenache.

The best time to buy a wine is when it's out of style.

Hunting for *just that wine* is probably a waste of your time.

Perhaps you just read about a great-sounding wine. Or maybe you want to recreate that perfect moment from that *one* time on that *one* trip. Or you saved a bottle and want to rebuy. There are moments it's worth making that effort, but just as often you're going to end up frustrated.

Here's the thing: More than virtually any other product, wine is sold in a decentralized way— most stores don't overlap their inventories. (And if you're seeing the same wine a lot, that's probably because it's a large production from a big winery.) The diversity's not a bad thing; think of it like being able to shop around in lots of great vintage boutiques. But it does make it difficult to find one particular bottle. The Internet has helped enormously (check out wine-searcher.com), and most good retailers can special-order you a bottle if it's available. But at the same time, with so many different wines out there, why not enjoy the thrill of something different? For several decades, the majority of wine customers admitted they bought mostly out of fear—and worried about trying something new. Those were dark days. Let's leave them in the past.

Wine's cool factor is confusing. As with fashion, tastes are always changing. It's worth knowing what's hot to drink *right now*, but that won't necessarily make you a more interesting, or informed, wine drinker. The matrix on the following pages breaks it down.

Not every new-wave wine is cool. Not every classic wine is uncool.

- _Pét-nat_
- "New" California
- Ribeira Sacra + Galicia Reds
- Red Burgundy
- Champagne ("Grower")
- Jura
- Corsica
- Beaujolais
- "New" Australia
- Txakoli
- Barolo/Barbaresco
- Valle d'Aosta
- Northern Rhône
- Saumur Whites/Reds
- Bierzo
- Etna Rosso/Bianco
- Savennières and Anjou Whites
- Traditional Sicilian Reds
- Schiava/Trollinger
- Other Loire Whites
- Chinon/Bourgueil
- Vermentino
- Georgian Wine
- Muscadet
- Carignan
- Friulian Whites
- Austrian Whites
- California Chardonnay (New Style)**
- Prosecco (Col Fondo)
- Assyrtiko And Other Greek Whites
- "New" Chile
- Savoie
- Sherry**
- Traditional Zinfandel
- South African Chenin Blanc

\longleftarrow |— TRADITIONAL —|

- Albarino
- Other New Zealand
- Rioja
- Tokaji/Hungarian Whites
- Roussillon
- Madeira**
- Portuguese Whites
- Verdicchio
- Alsace
- Sauternes
- Provence Reds
- Cava
- Soave
- Port
- Chianti
- German Riesling
- Frascati
- Semillon
- White Bordeaux

* = POPULAR BUT NOT COOL ** = RETRO-COOL

WINE COOLNESS MATRIX

IN FASHION

OUT OF FASHION

TECHNICAL →

- Provence Rosé
- California Pinot Noir ("Balanced" Style)
- White Burgundy
- Prosecco (Commercial)
- Oregon Pinot Noir
- Washington Reds
- Austrian Reds
- Vinho Verde
- Argentine Malbec
- Sancerre*
- Greek Reds
- California Pinot Noir (Big-Flavor Style)*
- Champagne (Big House)
- Most Napa Cabernets
- New Zealand Sauvignon Blanc*
- Southern Rhône
- Pouilly-Fumé
- High-Octane Zinfandel
- Languedoc Reds
- California Chardonnay ('90s Style)*
- Red Bordeaux
- White Zin**
- Brunello
- Ribera del Duero
- Most Pinot Grigios*
- Amarone
- Australian Shiraz

RULE 42

Never judge a bottle by its closure.

Once, corks were considered the best (and for several centuries, the only) way to seal a bottle. But good wine today comes with all manner of screw caps, crown caps, and more. In Australia and New Zealand, for instance, screw caps have become so common that cork now seems the odd choice to many. *Pét-nat* (see page 37) is typically released in a crown cap. Boxes, bags, and even cans are popular these days. The cork industry faced some tough times due to cork taint (see page 95), although it has made a lot of progress. But it's no longer a guarantee that a wine with a cork is the best thing on the shelf.

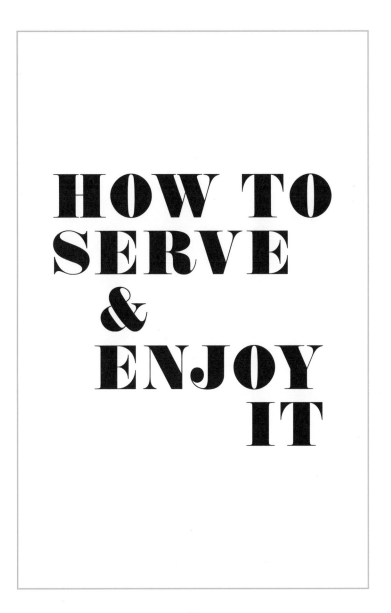

HOW TO SERVE & ENJOY IT

You're probably serving your white wine too cold and your red wine too warm.

It's tempting to leave white wine in the fridge and red wine on the counter, but neither will be exactly the right temperature. Serving a wine too cold will suppress its full aromas and texture, while serving it too warm can make a wine taste unfocused and simple—this applies equally to white wines and reds. Remember that a wine's temperature rises from the moment you pour it in the glass—that's to be expected, and it's an opportunity for you to enjoy the wine as it evolves.

The ideal way to maintain temperature is to store bottles in a wine fridge (or a temperature-stable cellar, if you've got one handy). But most of us can't do that. Instead, keep all your wines slightly chilled, and take them out in advance to warm up, depending on what temperature you need to reach. A half-hour should be plenty for most red wines. And if it gets too warm? Just put it back in the fridge, or even toss in an ice cube if need be. (No judgments on that.)

SHERRIES → 45°–57°F / 7°–14°C
(depending on style)

CHAMPAGNES → 46°–50°F / 8°–10°C
(cold is your friend here)

FRESH WHITE WINES → 47°–53°F / 8°–12°C

ROSÉS → 47°–55°F / 8°–13°C

RICHER WHITE WINES → 50°–57°F / 10°–14°C

ORANGE/SKIN-FERMENTED WINES → 53°–60°F / 12°–16°C
(treat like a rich white or light red)

FRESH OR DELICATE RED WINES → 59°–65°F / 15°–18°C
(room temperature, basically)

BOLDER RED WINES → 62°–67°F / 17°–19°C

One-third to slightly under one-half full is about right, depending on the glass. No more. This goes for restaurants, too.

A glass half-full is a wonderful thing, but not when it comes to wine.

This glass allows you to swirl, which properly releases aromas into the glass and helps you fully enjoy the wine. (see page 93).

This glass is awkward to swirl; there's not enough room for the aromas, so it doesn't smell like much. (Also, you're more likely to spill!)

Champagne is one of the most misunderstood wines out there. For a long time, it was positioned as a celebratory drink, not a "real wine"—people would buy perhaps one or two bottles per year, usually whatever familiar brand they knew.

But today the Champagne region is in beautiful revolution: hundreds of growers making exceptional wine from their own grapes, a new attention to quality and geography, more precision to the wines' flavors. These growers consider Champagne to be a wine first, meant to be enjoyed like any other wine—with an appreciation for craft and uniqueness, and most of all, enjoyed *frequently*.

So yes, Champagne may not be cheap. But it doesn't have to be expensive. It should be for pretty much anytime. Celebrate Friday. Celebrate having pizza. Celebrate a new season of *Stranger Things*. And ask a good local shop to introduce you to a Champagne under $50 you've never heard of before. Explore what's out there.

Champagne is for pretty much any day of the year.

Don't worry about the order of wines you serve.

Drink them however you like. If you want a rule of thumb: lighter to heavier, and white to red. But that doesn't factor in rosé or orange wines or sherry, or midmeal bubbles (or a mezcal shot), or the fact that meals today don't necessarily progress in the formal old ways. So pros often bounce between weights and styles of wine, entirely based on what they're in the mood for. (For more on pairing wine with food, see chapter 6.)

You can drink rosé any time of the year.

In fact, you should be drinking it year-round. It's the perfect way to split the difference between red and white. It goes with nearly everything. And yes, it's okay to drink a rosé that's more than a year old; the good ones age beautifully. (One of the great rosés of the world, from Rioja producer López de Heredia, isn't even released for several years after vintage.)

We expect wine to come in standard 750-ml bottles, but many of the best wines also come in *magnums*, or double-size bottles. Magnums are your friends—because they have twice as much wine, of course (hence the adage, "Magnums show you care"), but also because they age wine more slowly, thanks to a lower ratio of wine to glass surface, which means less wine in proximity to air or glass. They capture wines in a state closer to what they were at the winery, a more accurate snapshot of a wine as it was meant to be. And there is opportunity beyond magnums: *Jeroboams* (3 liters), *Salmanazars* (9 liters), and so on.

RULE 48

Drink your wine out of big bottles.

In fact, it's a good idea. Exposure to oxygen helps a wine "open," which is to say its scents become more pronounced as aromatic compounds are released into the bowl of the glass, its flavors are enhanced, its texture can soften, and it becomes overall more pleasant to drink. Just make sure you have the right glass for the task: one that tapers toward the top, with ample room for wine to slightly rise up the sides. And don't overfill it! (See page 88.) A tip: to practice swirling, place your glass on a flat surface and swirl it there, in tight circles. Even pros like to do this.

RULE 49

It's okay to swirl your glass.

Wineglass stems are there for a reason. Use them!

They're not to look fancy. The purpose of the stem is to provide a buffer between your hand and the wine—to prevent heat transfer from you (around 98.6°F / 37°C) to the wine (hopefully under 70°F / 21°C). So grab your glass by the stem and not the bowl—unless the wine is too cold, in which case you can cup the glass to warm it. Think about it as a physics experiment.

Also, stems help if you want to swirl a glass (see page 88) and bring out the wine's aromas. Think of them as providing a fulcrum that helps create an even circular swirling motion.

None of this is to say you shouldn't use stemless tumblers; they're useful at picnics, concerts, casual parties, and so on. But they'll never show the wine quite as well.

If you're trained to detect such things, smelling the cork can tell you something; you might sense a musty smell that could presage a problem. The wine industry makes a big deal about "corked" bottles (see page 54). This can cause wine to lose its scent or flavor, or to taste a bit like wet dog hair. Typically, this flaw comes from a problem with these compounds in the cork, although it can also occur in the winery. But today, corked wine isn't as big of a problem as people think it is. With improvements in cork-processing technology, somewhere around 1 percent or less of bottles have this problem, whereas it used to be closer to 7 percent. And that number has dropped as other closures become more popular. People talk about "cork taint" because it's heartbreaking to open a great wine and find it corked, but also because wine people—writers, especially—need something to complain about. Don't sweat it, but also don't hesitate to send back or bring back your wine if you think something's wrong with it. And know that smelling the cork won't necessarily tip you off to a problem.

Corks aren't the only thing to smell. Smell the glass before you pour wine in; wineglasses are a magnet for the smells of cabinets, so you may want to rinse your glasses before you use them. (And try, if you can, to store your glasses away from food and spices!)

Don't just smell your wine. Smell the glasses, the cabinets where your glasses are stored— and yes, even the cork.

Decant your wine.

Yes, whites too. And Champagne. Owning one decanter is good. Several are better. No, they don't have to be fancy. Decanting wine is about the process, not the equipment.

That process was traditionally meant to remove sediment from old bottles and to help soften and deepen the aromas of red wine. But white wines also can benefit. Sparkling wines can have their pressure slightly reduced. Decanting helps free the wine from the feeling of being locked up tight in its bottle. (Apologies to Christina Aguilera for this analogy.)

Choosing a decanter is all about the wine surface exposed to air. Not too wide.

If you don't want to buy a decanter, any pitcherlike vessel will do. Use anything from a quart-size Mason jar to a quality coffee pitcher (a clean one). At a barbecue joint in Nipomo, California, I once used a plastic Coke pitcher for a fancy Italian wine.

A half-size decanter can be useful, too—if you want to decant only part (for a taste comparison) or are drinking a half-bottle.

How to decant? Hold the decanter (or whatever) at a slight angle and gently pour in the wine; make sure not to splash unless it's a young wine that you want to give lots of

air, to make it more approachable. Gradually bring the decanter upright as you pour and carefully slow your pour as the bottle empties.

Some more quick tips: If you can, place the bottle upright an hour or two before you pour. Pour slowly. Use a light (candle, flashlight, even smartphone light) underneath the wine bottle to watch the wine. Translucent liquid is good. Solid is bad—that's deposits at the bottom you want to leave in the bottle. Stop pouring when you see solids. (But really only worry if the wine is ten years or older, and red.)

You'll never need more than two types of wineglass, three at most.

Here's how to choose proper wineglasses: one for white, one for red, one wild card if you have something special you love. No matter what you hear, you *do no*t need a separate glass for each type of wine.

The only useful color for a glass is clear. No etching. No paint. The point is to see the wine. After the stem (see page 94), the lip is the most important part of the glass. It should be thin, as small a barrier as possible from the wine to your mouth. And the bowl should taper back in toward the top, so the widest part is in the middle. (That helps concentrate aromas and also helps prevent spilling.)

And say good-bye to your Champagne flutes. Coupes, too. Most Champagne houses don't use them, as flutes diminish aromas; so do coupes, plus they let the bubbles dissipate too quickly. I drink my Champagne out of white-wine glasses, but some prefer "tulip" shapes that split the difference between too-narrow flutes and standard glasses. They help with the essentials: maximizing your ability both to smell and taste Champagne rather than just staring at bubbles.

MUST-HAVE

❶ All-purpose
 (red or white)
❷ White

OPTIONAL

→ If you love light reds
 like Pinot Noir, or
 Champagne, an
 additional glass might
 be worth it.
❸ Burgundy
❹ Champagne tulip

DITCH THEM

❺ Flutes (good for
 bubbles, bad for
 tasting wine)
❻ Coupes (bad for
 bubbles, good for
 cocktails)
❼ Stemless glasses
❽ Etched glasses
 (beautiful but not
 practical)

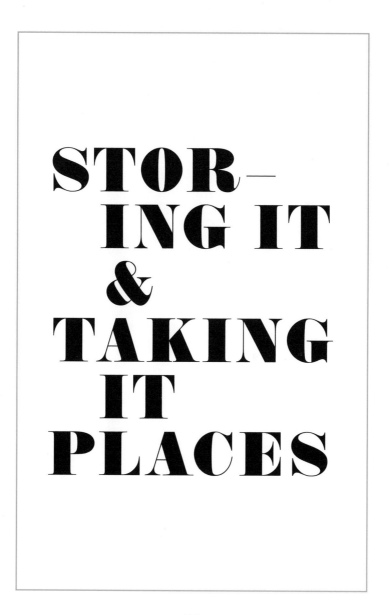

STOR–ING IT & TAKING IT PLACES

**Throw away
your kitchen
wine rack.**

Unless you always keep your kitchen under 60°F / 16°C (unlikely), you're slowly cooking the flavor out of your wine. Doubly so because most racks are kept near appliances—fridges, stoves—that give off heat.

If you want your bottles in the kitchen, invest in a small wine refrigerator or keep a few bottles handy in your fridge.

If you don't want to buy a wine fridge, the best place to store your wine is in the coolest, darkest, and most temperature stable place in your house. (Sad to say, this typically will not be the closet.) And even then, don't leave it sitting around too long. The longer it sits, the more likely it will lose its proper flavors.

**Keep your
open whites—
and reds—in
the fridge.**

They'll last longer—unless you're planning to drink them within a day. The real enemy of wine is oxygen: it makes wine not only evolve but also spoil, turning it into vinegar. Keeping your wine in the fridge will slow the spoilage. Even reds—just take them out thirty to forty-five minutes in advance. Most wine will last for at least three days in the fridge, but rarely longer than a week. So if it's a special bottle, invite friends and share.

They're inevitably too hot (unless they're too cold, but that's less of a problem). Trunks are especially awful for wine, as they can become little ovens. Leaving wine in the car for even an hour or two on a hot day can hurt it. So, if you drive with bottles frequently, consider keeping a small cooler in your trunk (helpful for food, too). Or invest in a few instant cold packs, used for sports injuries, to wrap around a bottle; they'll at least help stabilize the temperature for thirty minutes or so. If you're transporting wine on your bike, either put it in a backpack or make sure you have a basket. Bring an ice pack or neoprene holder. If you do this a lot, invest in a bungee cord to secure it. Let the wine sit for a while before you open it, especially if it has bubbles, since it will have been shaken up.

Cars are wine killers.

Keep a clean, empty half-bottle around.

That way, if you have about a half-bottle left at the end of the night, pour it into the smaller bottle and close it. Because of its smaller size, there will be less oxygen in contact with the wine (remember, it's oxygen that can make a wine turn bad).

"Cellaring" wine is about managing temperature.

Wine isn't perishable the way lettuce is, but it will change for the worse if it's not handled well. Generally, you want to store wine between 45°–58°F / 7°–14°C, depending on whether it's white or red. Never above 70°F / 21°C. That is why it's not great to keep wine in the kitchen. (Humidity matters, too, but that's harder to control.) If you can't keep your house at that temperature, which almost no one does, keep your wine in the fridge—wine fridge or regular fridge—or a cool cellar. Also: slow, small temperature shifts are usually okay (like in an underground cellar), but fast spikes can hurt wine.

In general, corks need to stay moist and in contact with the wine to be most effective. Standing a wine upright dries out the cork and can make the wine age more quickly or evaporate. It's less pronounced in the fridge, but even there, don't leave wine upright for more than a week or two. Champagne gets a partial exception because of its different cork; too much moisture can lead to *pegging*: The cork, which is designed to expand and hold the bottle's pressure, looks a bit like a mushroom. As its bottom part contracts, it can let in oxygen and make the wine age faster. But if you plan to drink your sparkling wine in the next few months, it won't make much difference.

Keep bottles flat on their sides.

If your open bottle is going downhill, don't pour it out.

Use it as cooking wine. Don't sweat it if it starts to sour; generally, it's turning to vinegar and can also be used to cook. (Just smell or taste it before you cook with it, as you would any other ingredient.)

There's great romance (and a lot of bullshit) about the age-worthiness of wine—opening a bottle from years past. But the vast majority of wines aren't really meant to age that long. A well-made Cabernet or Pinot Noir can often improve over ten years or more, and a small number of wines, like Barolo, need the extra time. And I've had many presumptively simple wines—good *cru* Beaujolais and even whites like Fiano—that are more interesting with age. But those are exceptions.

Old wine is meant to be about added pleasure—more complexity from more time in the bottle—but often it feels as if it's about endurance: Did this bottle survive that long? Quite simply, most don't. So don't assume that $8 bottle of Merlot that's been "aging" on your counter will be better just because you bought it five years ago.

By all means buy special, well-made bottles to keep for a special day: birth-year wines for your kids (get help from a good wine shop with this), fancy wines from a special trip. Store them properly. But most of the time, it's worth enjoying the fresh, fruity, so-called "primary" aspects of wine: immediate flavors that are pleasing *right now*. Don't let anyone tell you that you need to wait.

Drink your wine young.

Understand which wines are worth aging.

Aging is, in part, a holdover from the era when wines were often too sharp-edged to drink without a few years to mellow them. Modern winemaking has changed that, but most top-quality wines today should be able to improve and gain complexity for at least eight to ten years. (This was not always the case. Many of the fancy California Cabernets from about two decades ago had notoriously short life spans.)

Age-worthiness is an inexact science, but in general, the best wines from nearly any wine region, and most wines from the most famous regions, should improve with good cellaring. This includes a lot, everything from good Cabernet and other wines from the Bordeaux family (see page 60) to good Pinot Noir and fancier red Burgundy, and many white Burgundies and top Chardonnays made in a more restrained style. But it also includes wines from top Italian appellations like Brunello, Barolo, Etna, Montefalco, and so on, some of which really require aging. Top Rhône and Loire wines should age. German Riesling and good Austrian whites almost always improve. The best American wines definitely age (if not always as reliably).

What's most important to remember is that the wines you're buying for everyday drinking are *not* meant to age, which is okay.

A wine's aging potential isn't the only thing that will determine how it ages. Storage and so-called *provenance* (i.e., who owned the bottle before you), are almost as important. If a wine was stored improperly, it doesn't matter how old it is—it's probably going to be off. So, if you are going to invest in an older bottle, you should try to learn as much as you can about its past. Did you age it yourself? In that case, it's still worth asking: What were conditions like where it was stored? Was the temperature cold and stable?

Just as likely, you might find an old bottle available for sale. While auction houses and resellers have improved, the issue of fraudulent bottles is still a serious one. But that applies more to fancy, expensive wines—top Burgundies and the like. Many retailers do sell more modest older bottles, which can be very good. But be sure to ask: Did it come from a private cellar or the winery itself? What were conditions like in that cellar? How was it transported? Take a look at the bottle: Is the fill level of the wine close to the top? (If not, the wine may not be in good condition.) If you can see the cork, does it look soaked through? Did any wine seep up into the cork and out of the bottle?

If you want to drink your wine old, know its backstory.

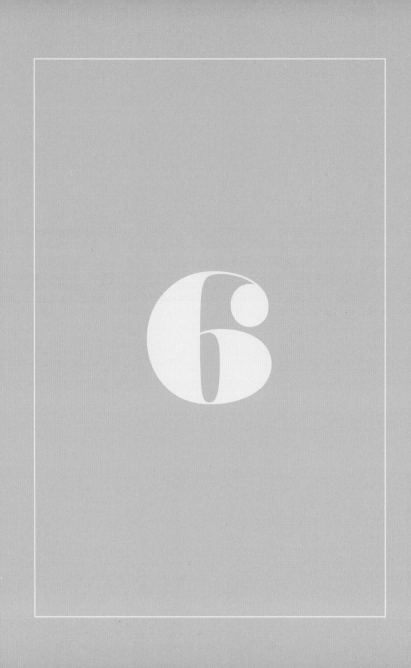

WINE WITH FOOD

The surgical-strike approach to pairing is cruel.

Endless fretting takes place over this simple question: what do I drink with what I eat? Books have been written. Experts hold forth. And almost always, this advice comes from a well-intentioned but false premise: that *one perfect pairing* is out there that will bring you inner peace and bliss. I love serendipitous matches between the flavors in food and wine, but even I'm nauseated by the obsession. (I think Americans are particularly vulnerable because we're a little more insecure about wine.)

In any case, stop worrying. There is no single perfect pairing. Drink what you like. A few things can be more difficult than others (see page 124) and we'll cover some easy strategies about those, but really—don't sweat it. We'll all get out of this alive.

Think about these four things in both the food and wine: acidity, salt and spice, texture and weight, and sweetness/fruitiness. Too much of any one thing will throw either food or wine off balance. That's why wine (and food) can be too acidic or too sweet. If a wine has lots of spice (like a peppery Syrah) without some richness to the texture or some fruit flavors, it will taste off-kilter.

Great pairings can come from like qualities: the mineral character in a Muscadet and the brine of oysters, or the chile-like aspect of Loire Cabernet Franc with Szechuan hot pot. But often the best pairings come from opposites: sugar in wine can help to cut sharp spice or acidity in food. (This is why off-dry Riesling works so well with much Thai cooking.)

And there's often scant attention paid to things like acidity and texture (see pages 50–51) which are often the most important elements in wine. It's why effervescent, high-acid Champagne, for instance, can go great with both the varied textures and the greasiness of pizza.

Don't worry so much about trying to match flavors. Great pairings often rely on other factors.

RULE 66

Nearly every pairing "rule" can be disproven.

Red wine with fish? White wine with meat? Steak with Champagne?

Again, it's about flavors and textures, not old rules of thumb. Champagne (which is often made from red grapes, pressed before they add much color) has acidity and structure (and if it's a rosé, some tannin, too) to stand up to dense, fatty steak. Many light reds (Schiava, for instance) are subtle enough to showcase the nuanced flavors of even white-fleshed fish, and other times fish will be prepared with tomatoes, olives, or other aggressive flavors. (Question: red or white with mussels marinara? Answer: either.) For that matter, some meat dishes— including schnitzel—are classically paired with a bright, aromatic (sometimes off-dry) white wine like Riesling. We eat in a world with far more diverse cuisines than the one encompassed by classic wine regions. So many of the old "rules" feel outdated and culturally myopic.

The point is to drink what you love with the food you like. Some extremes won't work but most fresh, young, relatively fruity wines will be very versatile.

→ Chablis + oysters

→ Beaujolais/fruity Zinfandel + barbecue

→ Champagne + pizza, bánh mì, or dim sum

→ Cabernet Franc + Szechuan/Shaanxi cuisine

→ White Burgundy/Chardonnay + roast chicken

→ Soave + summer corn

→ Rosé + eggs benedict

→ Champagne + steak or sea urchin

→ Red Burgundy + sushi

→ Fruity Riesling + hot dogs or pizza

→ Beaujolais + tacos or falafels

→ Sauvignon Blanc or Vermentino + chile verde
or chicken larb

→ Pinot Blanc + lamb korma or dal

→ Orange wine + lobster or spaghetti with bottarga

→ Asparagus + Grüner Veltliner, dry Riesling, dry Muscat,
some Sauvignon Blancs

→ Brussels sprouts + Sylvaner, fino sherry, white Rioja, dry
Chenin Blanc, Muscadet, and more

→ Soy sauce + Manzanilla or even Amontillado sherry,
or dry Madeira

→ Sushi + red or white Burgundy, Champagne, acid-driven
white wines

→ Vinegar + wine with ample acidity

Take a lesson from many Asian cuisines: when it comes to pairing, the sauce is often more important than the main ingredient.

Pairing rules usually talk about the main ingredient in a dish. But often that's not the guiding flavor. Proteins (vegetables, too) are profoundly impacted by how they're prepared and by the sauces with them. Different dishes using the same main ingredient could be rich and creamy, or sweet and tangy, or fresh and salty. Think about the difference between barbecue chicken and chicken korma, or rich coquilles Saint-Jacques and scallop sashimi, or even fettucine alfredo versus a spicy, tomato-based amatriciana.

One easier way to think about pairings is to focus not on the would-be "main" ingredient but on the preparation. This is the way that much of Thai, Indian, Chinese, and other Asian cuisines can be deconstructed. (So can Mexican and many others.) If the attention in Western cooking often remains on that primary ingredient—although don't forget that the *saucier* was one of the most important functions in French kitchens—it can be more helpful to think about the sauce or the spices and savory flavorings (ginger and so on) in a stir fry, or the marinade in a grilled dish.

There's plenty to be said for the old "grows together, goes together" adage, which is to say that a red Barolo is perfect with the heady pastas and truffles of Piedmont, and Beaujolais really is great with fatty Lyonnaise food.

But so many flavors today didn't emerge from traditional wine regions. I mean, try applying that rule to tamales or mapo tofu. It can be fun to recreate traditional matchups, but never be bound by them.

Wine and food from the same place can work great together—but so can pairings from far apart.

Wine people talk about foods that don't go with wine. Ignore them.

Yes, there are foods that can be tricky to match with wine. The sulfur compounds in asparagus and brussels sprouts can be problematic. The texture of oysters doesn't play well with tannins.

Importantly, there *are* wines to work with all these foods. Germans and Austrians inhale tons of asparagus each spring, washed down with Grüner Veltliner, Sylvaner, and other things. Oysters are wonderful with most fresh white wines, plus a good many light reds if the oysters are cooked. And some alleged no-nos—soy sauce? sushi?—feel downright contrived, meant to make us insecure. So drink wine with these if you like.

That said, there is one big flavor killer in wine: *oak*. The woodiness and vanilla-like sweetness can steamroll more savory and subtle flavors. This isn't to say oaked wine won't work with food, but unoaked or lightly oaked wines are far more versatile. Rule of thumb? If you can taste the oak, the wine may clash with food (unless you're eating smoked beef jerky).

One more wrench in the gears: *sugar*. A little sweetness can counterbalance some aggressive flavors in food, but many wines (like much New Zealand Sauvignon Blanc) have high, if hidden, levels of sugar (see page 52).

Sparkling wines, not just Champagne but choices from around the world, work with a remarkable range of foods. I've solved many a tricky mix of dishes—she ordered lamb, he ordered sole—this way.

And remember: beer qualifies as bubbles. Beer pairings have their own complex guidelines, but the effervescence—as with fizzy wines—makes them more versatile.

If all else fails: bubbles.

DINING OUT

If a glass of wine costs more than one-quarter of the bottle, skip it.

A 750-ml bottle contains around five glasses of wine. Factoring in some leeway (perhaps you get an extra-big pour), that means that if you're paying more than one-fourth of the bottle price, you're being charged a premium. That's especially so because "glass pour" wines are often discounted to restaurants. So certainly, you shouldn't be paying extra for the "privilege" of having a glass instead of a bottle. In any case, a glass price that's one-fourth the bottle price is reasonable economics; one-fifth the bottle price is a deal. One-third? A ripoff.

On that note . . .

A glass of wine in a restaurant should be five ounces.

More is generous. Less—unless you've ordered a half-glass or a tasting-size pour—and you're being shortchanged. This isn't supposition; it's math based on standard restaurant economics (see above).

$$750 \text{ ml} = \text{around 25 ounces}$$

$$\frac{25 \text{ ounces}}{4 \text{ to 5 glasses per bottle}} = 5 \text{ to 6.5 ounces per glass}$$

It's also why half-glasses can be a good idea; they give you flexibility and often contain a bit more than a true half-glass (2.5 ounces). Note that a good restaurant should have glasses that can contain a five-ounce pour without the glass being more than half-full.

"That's fine, thanks" should do it. If you need to go all referee and put a hand out, that's regrettable—on the server's behalf, not yours—but still fine. You're the customer. (It is, admittedly, a bit tacky to do the opposite: ask the server to keep pouring.) A good server will pour you the correct amount.

If a server is pouring too much wine in your glass, stop them.

RULE 74

Big wine lists are not better than small ones.

Stick to that adage: it's not the size, it's what you do with it. Historically, lists were given more credit—and awards—for being comprehensive. And a doorstop-size list can be a lot of fun. But editing is an equally important skill for a sommelier, choosing the best (or most fascinating) wine of each type rather than flooding the zone. In the words of London sommelier Michael Sager, customers don't need "five different Chablis that will go with their fish; they need just one." And most modern restaurants don't have the space to store hundreds of bottles. So if it's done right, a well-edited one-page list can be as rewarding as a fifty-page list.

**Ordering
wine is a
conversation,
not a test.**

But make sure it's not a one-sided
conversation. You and the sommelier need to
be talking *with* each other, not *at* each other.
There's no such thing as the perfect choice,
so choose the wine that makes you happy.
What does that require?

→ Be clear about the
types of wine you
like. If the server
or sommelier's
suggestion makes
you uncomfortable,
just ask what other
ideas she might have.

→ Be clear up front
about what you
want to spend. If a
suggestion is too
expensive, say so. If
you don't want to talk
money at the table,
point to a wine that
is close to your price
range: "What about
something more like
this?" Or "I really
enjoy wines from this
region." They should
get the hint.

→ It goes without saying that a restaurant staff should *always* know its wine list better than you. Asking them which wine they like best is a common tip. But that's not as helpful as asking for two or three suggestions of what goes with what you're eating. Let them edit their wine list for you.

→ If they can't provide answers, ask them nicely to ask someone who can. This is why we pay extra for wine in restaurants: to have it served by professionals.

→ Ask a sommelier which wine really excites her. If it's not in the lower half of the list's price range, ask again.

→ If you're stuck and the restaurant isn't too fancy (and even if it is), ask for a small taste of a wine by the glass you're interested in. Never more than two—and obviously, this only applies to wines they're pouring by the glass. If you really don't like the wine they suggested, tell them right after you taste it: "This isn't quite what I had in mind." Today, it's generally okay to send back a suggestion—but not once you start drinking it.

→ Finally, sometimes wine isn't the thing to drink. In addition to the explosion of cocktail talent, restaurants are also working hard to better curate their beer, cider, and even sake and soju choices (and to find interesting nonalcoholic choices). All of these are smart ideas, depending on your mood.

There's no formula to finding the best value on a list.

For years theories have been circulating for rooting out deals: choose the cheapest wine, or maybe the second cheapest.

Remember that sommeliers have heard these "secrets," too. With time, you might recognize pricing on a few benchmark wines, but those are precisely the wines likely to be priced to distract a nonexpert. So toss out those alleged "rules."

A good restaurant stands behind all its choices and knows that customers today can check prices in an instant on their phones. In general, it's fair to expect bottles to cost twice what they do in a wine shop. Restaurants have to absorb the cost of storage, glassware, and professional service, and like it or not, wine sales help most restaurants cover the bills. But once a markup heads north of twice retail, it's fair to question whether prices are being padded.

A few more rules of thumb:

DO YOUR HOMEWORK.

That means checking a wine list beforehand to see what bottles cost, and if you're curious, compare them to retail prices. Wine pros do this in their heads every time they dine out. A restaurant that loves its wine list will share it online—with prices. (A restaurant that doesn't publish prices, for food or wine, arguably has something to hide.)

THE MOST OBVIOUS WINES ARE USUALLY THE WORST DEALS.

Chardonnay by the glass, well-known brands, Champagne, and so on.

NEARLY EVERY LIST WILL HAVE A SECTION OF LESSER-KNOWN WINES THAT ARE SOMEONE'S PERSONAL PASSION.

It might be Austrian or Greek wines, or may be marked something like "Interesting Whites." In general, these will contain the best deals; sommeliers almost always discount the chance to share their passion.

CHANCES ARE, IF YOU EASILY RECOGNIZE THE CHAMPAGNES ON THE LIST, YOU'RE PROBABLY PAYING TOO MUCH FOR THEM.

These bottles are the most likely to be discounted at wholesale. They are also most likely to receive extra markups because they're familiar names, and some diners equate them with prestige, so they'll opt for them regardless of price. (That said, this is less true today than it has been in the past. So many people know the retail cost of, say, Veuve Clicquot that wise restaurateurs have stopped overcharging for such wines.) A tip: don't overlook non-Champagne or non-Prosecco sparkling options, which often can be good deals.

**Wine should
come to
the table
at the correct
temperature.**

This is one major aspect of why we pay more for wine in restaurants: proper handling. Sadly, it's harder to find than it should be. Too often bottles are stored out on counters or on bar shelves, versus in a wine fridge. (See pages 86–87 for proper serving temperatures.)

If a wine arrives too cold, insist that it sit out to warm up, or ask for it to be decanted. (Handling it will warm it slightly, and the decanter glass will be warmer than the bottle.)

More commonly, wine arrives too warm, especially red wine. Ask for an ice bucket—yes, even for a red wine—and explain politely that it needs to cool down a bit. (Hopefully, the restaurant takes that as a subtle tip they're storing their wines improperly.)

That means one person should never hog the wine list. Ask for additional lists if you like. If Big Spender decides he wants to go large, politely counter with a less-expensive bottle. If he doesn't get the hint, you could always try and make a joke: "It is *so nice* of you to treat us to such an impressive bottle." Then make a mental note that this person is a lousy dining companion.

Also, be mindful that wines are poured equally among guests, especially since some drink faster than others.

RULE 78

If you're splitting the bill, remember that drinking becomes a communal effort.

Feel free to cede that to your guests, and certainly ask what they'd like to drink. But—your wallet, your pick. And if you're splitting the bill but want to drink something special, offer to buy it for the table. It's an excellent touch of karma.

RULE 79

If you're picking up the check, the wine choice is ultimately yours.

RULE 80

You have rights as a wine customer.

Unless you're at the ballpark, a bottle should always come to you closed, even if it's then taken away to be opened. While sommeliers often like to open bottles at a service table, it's fair to see that you're receiving an unopened bottle (from the cellar stock, presumably) and not one that's already open.

You should always be allowed to taste a bottle that you're offered, and you should always do so. If it's a recommendation and you really don't like it, that's your chance to say so. It's better to *ask* about choosing a different bottle than to demand it, but most good restaurants today will take back a suggested bottle a customer doesn't like—*if* you say so right away, not halfway through. There is an occasional tendency among sommeliers to serve a much more basic bottle to guests who send one back. That's bad behavior and is still mercifully rare.

Smell the cork if you like although it may not tell you anything (see page 95).

Sometimes you're going to get a faulty bottle (see page 53). It's sometimes hard to catch; even my wife and I, both wine professionals, often argue over the condition of wines we're served in restaurants. If it doesn't taste right, ask the sommelier to taste it; a good one has already done that before serving it to you.

(If a server is pouring, ask him if he could have the sommelier or manager check it.) If it really does seem wrong, it's usually fine to send wine back—although a good sommelier will be clear if they think a wine is in the correct condition. But *never* do this after you've started drinking it—with one exception: sometimes a flaw takes a few minutes to show itself. If the wine suddenly starts tasting notably worse, politely point out to the server that the wine seems a bit off. A good server will have it checked for you.

DRINKING IN

Don't be the guest who brings the cheap stuff. But that doesn't mean you have to splurge.

If you're bringing wine as a guest, how much should you spend? A rule of thumb: the cost of a main course at a restaurant you'd go to with your hosts. Remember that expensive doesn't equal special. Sometimes a brilliant, unique $12 bottle is the perfect house gift.

What matters most is to choose something that shows you thought about your choice and your host's taste. Thoughtfulness always outweighs a price tag.

Don't assume your bottle will get opened.

As a host, it's polite to open and serve any bottles your guests bring with them. That said, as a guest, you shouldn't expect your host to open the bottle you've brought.

If the bottle is specifically meant for that night, here's a tip: open it before you go and say it needed decanting, which perhaps it really does—whites, too (see page 96). And if you're worried your friend may not get the hint, ask beforehand: "I was thinking of bringing over a special bottle to go with dinner. But I wanted to check, since maybe you already picked out what we'll be drinking."

If you're hosting a party, how much wine you buy depends on your friends—and the type of party you're having. In general, plan that every guest will drink at least two glasses of wine. A bottle contains just over four glasses—I know I said five in on page 128, but party pours are bigger than restaurant pours.

So here's your rule of thumb: one bottle per two guests. *Then* add at least one more bottle to make sure you don't run out: four guests = three bottles, eight guests = five bottles, and so on.

Buy just a bit more wine than you think you'll serve.

Just because you've got a dozen or more people coming over, it isn't an excuse to use Solo cups. If you entertain a lot, get some cheap stemmed wineglasses that can go in the dishwasher, and keep them for parties. If you're worried about those stems being knocked over, get a cheap stemless set. And if it's more casual, you can always get plastic versions of those stemless wineglasses, like those made by Govino. Solo cups are for beer.

Use glassware to match the party.

Offer a variety of things to drink.

Unless it's for a dinner party, make sure red, white, rosé, and sparkling are represented—or at least on offer—so that your guests have options. Depending on what you're serving and what the weather's like, you may want to lean more heavily on one style: if you have a cocktail hour first (or it's a cocktail party), add a couple extra bottles of sparkling wine.

Finally, this goes almost without saying . . .

Make sure to buy wines you want to drink yourself.

It's good incentive to buy a bit extra, and worst case, you'll drink the overage yourself later.

Keep a few bottles on hand at all times, preferably one white (something versatile like unoaked Chardonnay or Verdicchio), one red (something relatively light-bodied, like Pinot Noir or good Beaujolais), and one sparkling. If you don't have the space, just keep a bottle of fizz in the fridge.

RULE 87

Always be prepared for the instant party.

Preferably one dry white and one sweet red (and one "blanc" or "bianco," if you like). They're great for aperitifs *and* for making cocktails. Store opened bottles in the fridge—and buy half-bottles because you ideally should use a bottle up in a week or less (says the guy who leaves them in his fridge for weeks on end). Incidentally, the same goes for dry sherry.

RULE 88

Invest in a good half-bottle or two of vermouth.

Don't save a great bottle for anything more than a rainy day.

One of the great fallacies of wine is that waiting makes it better. No doubt, there are many wines that get drunk too young, and patience can be a virtue when it comes to the most important wines (see page 111). But even most top wines today can be enjoyed relatively young.

This isn't to say you shouldn't collect and age wines if that's your interest. But too often many of us—myself included—keep wines around longer than we should, either because we're waiting for *just* that moment or because we forget that we're saving it. (That can be a happy mistake if you find something that's been unintentionally aged and still good.)

Nothing will give more pleasure than opening a great bottle with people you like, and enjoying the fact it has been saved for that moment, even if you didn't really save it for that moment. So don't horde those special bottles. Open them, enjoy them, and buy more—because there's always more.

ACKNOWLEDGMENTS

This very modest book turned out to be much more of a challenge than I expected, and it never would have happened without the help of a lot of people. First and most of all, thanks are due to my wife, Valerie—for your love, support, and advice throughout the entire process. You know so much more about wine than I do, and yet you *always* remind me that knowing is only half the equation. If we can't share that knowledge in the right way, it's worthless.

Deep thanks are also owed to:

My friend and literary agent Katherine Cowles, for her help and infinite patience in making sure this book—new territory as it was—got done right.

Aaron Wehner of Crown and Ten Speed Press, who has been supportive from the very start about me doing a different kind of project, and who was essential in shaping its concept and form.

The entire team at Ten Speed for putting together a complex project on a daredevil timeline; first and foremost my editor, Emily Timberlake, who has been a terrific friend and ally in ensuring all

the pieces came together; Lizzie Allen, our amazing designer, who finessed a visual concept that was friendly but not frivolous; Jean Blomquist and Dolores York, our copyeditor and proofer; David Hawk and Allison Renzulli, for their dynamic work to spread the word; as well as Emma Campion, Serena Sigona, Hannah Rahill, and Windy Dorresteyn for their support and help.

María Hergueta, our illustrator, whose work is always so beautiful to see. María found just the right visual language to express often complex ideas. This book wouldn't have worked without you.

My friend and editor Talia Baiocchi at *PUNCH*, and the whole *PUNCH* team, who always challenge me to be better, and who gave me a space to try out ideas for *The New Wine Rules*.

My outside proofreaders: Aimee Haber, Steve Matthiasson, Carole Meredith, Erin Nebel, Tegan Passalacqua, and Juliette Pope. Your feedback, professional and civilian, has been so candid and so valuable. You made this a far better book.

The many winemakers, wine sellers, sommeliers, and other professionals who I've tormented with questions over the years, and who helped me bushwhack a path to expertise. I can't thank you enough for your patience and time.

Finally, a deep thanks to my mom. You've always reminded me that sometimes we have to slow down to help everyone else understand what seems obvious in our heads.

Published in the United States by Ten Speed Press, an imprint
of the Crown Publishing Group, a division of Penguin Random
House LLC, New York.

www.crownpublishing.com
www.tenspeed.com

Ten Speed Press and the Ten Speed Press colophon are
registered trademarks of Penguin Random House LLC.

Library of Congress Cataloging-in-Publication Data
Names: Bonne, Jon, author.
Title: The new wine rules : a genuinely helpful guide to
 everything you need to know (and nothing you don't) /
 Jon Bonne.
Description: First edition. | [Berkeley?] California :
 Ten Speed Press, [2017] | Includes index.
Identifiers: LCCN 2017024717
Subjects: LCSH: Food and wine pairing—Popular works. |
 Wine and wine making—Popular works.
Classification: LCC TX911.3.M45 B66 2017 |
 DDC 641.2/2--dc23 LC record available at
 https://lccn.loc.gov/2017024717

Hardcover ISBN: 978-0-399-57980-6
eBook ISBN: 978-0-399-57981-3

Printed in China

Design by Lizzie Allen

10 9 8 7 6 5 4 3 2